NOT WITHOUT TEARS

The Life of Favell Lee Mortimer

Front cover: The old schoolhouse at Fosbury, Wiltshire where Mrs Mortimer set up her first school and developed the material which became her first and most popular book.

NOT WITHOUT TEARS

The Life of Favell Lee Mortimer

Christina Eastwood

Christian Year Publications

ISBN-13: 978 1 912522 33 0

Typeset by John Ritchie Ltd., Kilmarnock
Printed by Bell & Bain Ltd., Glasgow

Contents

Acknowledgements

Thanks are due to the following:

Mr John Creasey of the Runton Parish History Society for valuable information and leads.

Mrs Anne Powers, family history researcher, for her comments, information and suggestions.

Kelly Dyer, local historian and Library Officer, City of Onkaparinga Libraries, South Australia for information about Louisa and Gabriel Cox's life in Australia.

Aileen and Phil Haywood for information about the Fosbury Schoolroom.

The Evangelical Library for access to H.D. Budden's *The Story of Marsh Street Congregational Church, Walthamstow* (Margate, 1923)

The staff of Penrhyndeudraeth local library for tirelessly tracking down the books I needed.

Not Without Tears

Introduction

"Remember the four essential qualities of an opening sentence. It must be short, easily understood, interesting, and conciliatory,"[1] commanded the subject of this biography. I will do my best...

They were right! Kind family members assured me that the drab old copies of *Peep of Day* they passed on would be useful for my toddlers. I soon found that they were the best Bible books for tiny children that could be had – despite their off-putting appearance. I was prompted to find other books by the same author. We devoured *Line Upon Line*, *Precept Upon Precept*, *Streaks of Light*.... Who was this author whose pithy little chapters always seemed to hit the nail on the head when it came to what you wanted your children to know? I was curious. I discovered that the books were once anything but obscure or unpopular and my researches uncovered an influential and interesting character who moulded generations of Christian thought – literally from the cradle.

As I disentangled the life story of Favell Lee Mortimer from the mixture of laconic and fragmentary sources that are publicly available, I could not stop myself from writing it down. It was such a fascinating story that I wanted everyone to know about it. I hope you will enjoy reading it as much as I enjoyed the research and writing. Most of all, I hope it will inspire you to keep on teaching the plain, simple and complete Gospel story to little children in language they can understand. That was Favell's passion in life and her story should inspire every Sunday school teacher, every beach missioner, every holiday Bible club leader and every Christian parent to keep on planting the precious seed.

Chapter One (1802-1826)
Grace and Gracefulness

Favell Lee Mortimer (1802-1878) was one of the most successful Christian authors of the nineteenth century – in fact probably of all time. Her works were printed, reprinted, translated, pirated, sold all over the world and followed by a host of lesser imitators on both sides of the Atlantic.[2] Her books were read in countless households, rich and poor alike. She far outsold her favourite Bible commentator – the influential Thomas Scott – and her books were devoured from cover to cover – unlike commentaries which often remain on shelves, rarely consulted. The contents of her books lingered in innumerable minds; a witness to the truth even if their teachings were eventually ignored or discarded. Favell Lee Mortimer shaped the outlook of several generations because she wrote for children and what she wrote was, as she put it, "a series of the earliest religious instruction the infant mind is capable of receiving."[3] "I can see our copy now," wrote F. B. Meyer in 1901, "and [I] would give much to recover it from the waste of years." He was one of millions who could recall that her books "gave us the first thoughts of God."[4]

So who was this remarkable lady? Was she bad-tempered, scornful and rude as one modern writer has claimed;[5] her bestseller, "one of the most outspokenly sadistic children's books ever written?"[6] or did she have, "a genius for conveying the things of God to the young and opening hearts?"[7]

In fact, Mrs Mortimer's life story is without parallel even in Regency and Victorian England and an incredible testimony to God's providence and God's grace. To read it is to walk through

a portrait gallery of Christians (some now almost completely forgotten) who in their day were greatly used of God. Rowland Hill, William Howels, George Collison, Hugh M'Neile, Basil Woodd, Maria Stevens, Dervey Fearon, Harrington Evans... the list goes on and on. Some were scholarly, some were eccentric, some were rigorously orthodox, some were wrong-headed, but they all played a part in her life. The modern reader will be surprised at the colourful variety of the characters on show in this unique exhibition. More to the point, the subjects of the portraits are a key to her own output for Mrs Mortimer was adept at squirrelling away ideas, techniques, methods and even anecdotes and putting them to her own use years later.

But her life also gives an understanding of the darker side of early nineteenth century England. The London society into which Mrs Mortimer was born was, despite a sophisticated veneer, a depressing place. Standards of behaviour in private, and even in public, were at a very low ebb. George, Prince of Wales (1762-1830), later Prince Regent, then King George IV and leader of fashionable society, was extravagant and dissolute. His immoral way of life dragged down others, forming a chain of misery that reached from the top to the bottom of the social scale. On the outside Georgian and Regency society was elegant, but beneath its decorous surface lurked something sinister. The wallpaper was exquisitely striped with graceful floral patterns, the Chippendale furniture was dainty, the gorgeous marble Adam fireplaces were imposing, society manners were polished and gracious, the dress fashions were classical and becoming. But, although appearances were elegant, morals were debased. Society was eaten up with a depravity which threatened to destroy it.

In France there had been a political revolution which led to tyranny and misery. It was a revolution which had begun with great swelling promises of *Liberté, égalité, fraternité* but which had ended in oppression and suffering. England too underwent a huge change but it was totally unlike the revolution in France both in origin and in outcome. George Whitefield, the Wesley brothers, William Grimshaw, Howell Harris, and a host of lesser known preachers took the gospel message of salvation from sin through faith in

Jesus Christ to almost every corner of the land. The change was as revolutionary as anything that happened in France although totally different in character and effect. One of the outcomes, during Mrs Mortimer's lifetime, was a moral reformation.

When Mrs Mortimer was a child, the horrors of the French Revolution were still reverberating across the Channel. She was thirteen when the Battle of Waterloo ended the years of war, fear of invasion and associated economic distortion that had lasted right through her childhood. More importantly, the events which shaped her life were intimately bound up in the change in moral attitude in England that followed the religious revival. Her life illuminates the ethical landscape "before" and "after" with peculiar and poignant clarity.

Favell Lee Mortimer neé Bevan, was born on July 14th 1802, second daughter of David and Favell Bourke Bevan. Her mother, Mrs Favell Bourke Bevan,[8] was the daughter of a successful attorney,[9] Robert Cooper Lee (1735-1794), who had made his fortune in the West Indies. He returned to England in 1771 with his West Indian mistress, Priscilla Kelly, and their younger children to join their two eldest children who had already been sent to England to school. Priscilla was what was known in eighteenth century Jamaica as a *quadroon,* that is her mother was a *mulatto*[10] and her grandmother black. It is probable that her grandmother was a slave but her mother was free.[11] Once home in England, Robert married Priscilla (which would have been an unthinkable thing to do in Jamaica) before Mrs Bevan was born. She and her siblings were in West Indian terms of the time *octoroons* that is, they had a black slave great-grandmother although their other forebears were white. The children's colouring and general features were probably such that their African ancestry would not have been at all obvious to anyone in England. Robert Cooper Lee, "went to considerable lengths when in England to ensure both a legal marriage and the legal status of his older children as far as was possible, who under the law at the time would always be illegitimate."[12]

Despite their father's efforts to rein in their expenditure and encourage them to engage in useful business, three of Mrs Favell

Bevan's brothers, Robert, Matthew and Scudamore, became spendthrifts; friends of Prince George's set who were well liked for their very good looks by such disreputable characters as Beau Brummell and the Prince's various mistresses. These three members of the family were constantly in debt, especially after their father's death. So when the son of a rich banker on the edge of their circle showed an interest in their pretty little seventeen year old sister, the brothers (including also Richard who, unlike the other three, at least knew how to hang onto money) and their elder sister were delighted. Here was security for her and perhaps even a way out of their own permanent financial difficulties. They firmly persuaded her to marry David Bevan – whatever her own inclinations might have been.

David Bevan (1774-1846), Mrs Mortimer's father, came from a background that was opposite in almost every respect to that of his wife. Financially secure and connected with the anti-slavery movement, the banker David Bevan, was of Quaker stock. He was descended from Robert Barclay (1648-1690), the defender of the Quakers, and he was also related to prominent Quaker families such as the Gurneys and the Buxtons, supporters of William Wilberforce's great campaign to free the slaves. His brother George Bevan (1782-1819) and other brothers were evangelical Church of England ministers. One might suppose that the family of solid Barclay's Bank partner David Bevan would have been as distant from the bitter consequences of dissolute living as it was from poverty. But David Bevan and his pretty and innocent bride were to be involved in tragedies not of their making.

The Bevans had been married some six years when the first disaster struck. David's wife was greatly attached to her brothers, despite all their faults. The youngest, Scudamore, who was closest to her in age, was her special favourite. She was devastated, therefore, when in 1805 he took his own life. Insanity was the official reason[13] although he does not seem to have had any history of mental illness. He was, however, heavily in debt through gambling. A few years later, Mrs. Bevan's brother Matthew, already quite notorious for his scandalous elopement followed by a high profile legal separation, also committed suicide. Matthew

had visited the Bevans, leaving a ring behind on the mantlepiece: only after he killed himself did Mrs Bevan realise it was his farewell gift. If that was not tragedy enough, the eldest brother, Robert, by this time bizarrely hypochondriacal, was also to die by his own hand a couple of years later.[14]

One can only guess at the strain all this placed on the family. Mrs Bevan took charge of Scudamore's illegitimate daughter, Marian Farmer,[15] and brought her up, either at home with the other children or by sending her to boarding school. Mrs Bevan and her husband seem to have had a somewhat cold relationship and given the circumstances it is not surprising. The sordid tentacles of Prince George's evil cronies had reached, like those of some venomous octopus, into baby Favell's well-off and respectable family, poisoning relationships and straining her parents' marriage. Little Favell herself must have understood none of all this, but surely she felt it.[16]

David Bevan, given his background, was presumably familiar with the gospel, but during her early life Mrs Bevan seems never to have heard the good news of salvation through faith. Despairing of ever hearing anything helpful in church, she gave up going; preferring instead to spend the time reading the New Testament. Once she did hear something other than a philosophy of salvation through works when she attended a service conducted by Richard Cecil (1748-1810). Cecil was an evangelical associated with William Wilberforce's "Clapham Sect"[17] who ministered from 1788 at St John's Chapel, Bloomsbury. This was about half a mile from the Bevans, who lived in Russell Square at the start of their marriage. But although struck by the message, Mrs Bevan did not understand it and certainly there are no available records of her going to St John's regularly.

A baby boy was born to the Bevans in 1799, but sadly this first child was either stillborn or died. Baby Louisa was born in 1800 and then eighteen months later, Favell Lee Bevan was born. A third daughter, Frederica, was born in 1803 and then, after Matthew's suicide in 1808, Mrs Bevan was keen to move to the country. Perhaps under the circumstances, which may well have

been made worse by a series of miscarriages, she was suffering from depression and wanted to be away from the bustle of London society. Probably too, she felt that the country air would cure her from the migraines from which she suffered.

The family accordingly moved to York Place, Marylebone, then close to open fields. Here it was that they encountered a most unusual lady evangelist whose influence was to change their family forever.

By this time, the three girls (at about three, six and eight) were old enough to need a governess. From the character of the lady they employed for this task, one might guess that she was recommended to them by someone from David Bevan's side of the family – maybe one of his brothers – who was anxious that the little girls should hear the gospel news which their mother could not tell them. Accordingly, at this point in Favell's childhood, there flits across the stage the enigmatic but impressive figure of Miss Clara Clare.

What little is known of Miss Clare can be briefly told. She was a day governess, returning home to look after her aged mother and orphaned niece each evening. From this it can be guessed that she lived somewhere in the nearby area. Her age is not known. All that can be found out about her appearance is that she was tall, ungainly and (rather unusual for a governess one would imagine) untidily dressed. But above all she was a Christian lady and she made a lasting impression on the whole family. By the faithful and loving discharge of her lowly duty she became an example – a model even – on which much of Favell's life work was based.

Miss Clare was a very gifted teacher of small children, "she was clever, and taught them so well that they liked whatever she taught them."[18] Best of all, "[s]he brought the gospel, the full free gospel to the young mother, who drank it in as eagerly as the thirsty ground drinks in the cooling stream."[19]

A great change in the family began. Mrs Bevan naturally wanted to go to church now and asked Miss Clare's advice, probably

not wishing to encounter the useless dead preaching she had previously heard. Miss Clare recommended the oddly named (or rather, oddly spelt!) Basil Woodd. Mr Woodd was minister of the Bentinck Chapel in Lisson Street, Paddington, about half a mile away. He was a warm-hearted gospel preacher with a great concern for young people. Mrs. Bevan began to grow under his ministry. The children's nurse also listened to Miss Clare and was converted.

Miss Clare's knack of telling Bible stories captivated little Favell and everything she taught her sank deep into her heart. But, as is often the case with tiny children, it was to lie dormant there for many years. In Favell's case, another family crisis years later led to its springing up fruitful at last. What long term effect Miss Clare had on the youngest girl, Frederica, is not recorded in any of the available sources, but it is known that a lasting change took place in the eldest, Louisa, straight away. Louisa would later go through a period of agonising backsliding, but it was Miss Clare who led her to know and love Jesus as a little girl and her conduct changed at once as a result – a sign of a real work of grace in the heart. Now she restrained her childish tantrums and also lost her fear of thunderstorms, sure of her heavenly Father's protection.

When the family moved to Walthamstow, David Bevan accompanied his wife in her search for a good church in the area. They rejected St Mary's Walthamstow, Woodford Parish Church and other places of worship and almost despaired of finding gospel preaching until the children's nurse came home one Sunday evening saying that she had found a good preacher at last.[20] This was the Rev Dr George Collison (1772-1847) of the Independent Church, Marsh Street, Walthamstow. Dr Collison was a Yorkshireman who was president of the nearby Hackney Academy, a venture started by the famous preacher Rowland Hill and others with the object of training men to evangelize in rural areas. Dr Collison soon became a personal friend of the family. It could be inferred that David Bevan may have been converted under his ministry although, strangely, appeals made by his daughter Louisa and her husband when he was on his deathbed indicate that he may never have come to share his wife's faith.[21]

Walthamstow was too far for Miss Clare to travel on a daily basis, but she still maintained her teaching link with the family. She would arrive on Friday and stay overnight, departing on Saturday, thus giving two days of instruction per week. On the other days, Mrs. Bevan taught her children herself. She began each day with prayer and Bible lessons.

The Bevans' house, Hale End, Walthamstow, with its large garden for playing in, delighted the girls. A new baby arrived, Robert Cooper Lee Bevan (1809-1890), named after his maternal grandfather. Favell adored "RCL," as he was sometimes called when he grew up, and he was her favourite brother for most of her life. She spent so much time helping to look after the new baby that she earned herself the nickname "Little Mama."

Dr Collison proved a great blessing to the family, especially Louisa. Despite a reputation for scholarliness, his sermons must have been accessible since the girls regularly wrote accounts of them afterwards of their own free will and brought them to their mother for her corrections and comments.

The girls also enjoyed learning hymns and Dr Collison had all the young people in his church memorise the Westminster Shorter Catechism. He called at Hale End from time to time to hear the children repeat it and also suggested that they write "themes" or essays on Scriptural topics. Here, once more, there is a glimmer of the future: Favell's "themes" surprised and delighted the minister. He could see that she already had a talent for writing – and writing of a specific sort. Young as she was, Favell was already displaying a gift for distilling Bible teaching in simple words. It is strange to hear of such a gift in one who was as yet unconverted, but with hindsight God's gracious hand can be seen preparing her for her life's work. She was learning as a child to write for children.

This serious sounding childhood also included some very imaginative fun. "The children's chief delight and employment in playtime was describing imaginary events, and this they did with as much eagerness and interest as if the events described had been

real. Each took a part; one was hero or heroine, the other regulated the circumstances. Their minds were so much engrossed by these scenes, and in planning events, that they lived in a world of their own invention."[22]

Mrs Bevan continued the children's education as they grew, reading to them in the evenings and introducing them to poetry. She read them Milton's great epic poem *Paradise Lost* and Favell was greatly struck by it. She was deeply affected by the poem's unfolding of the story of this world's sin and misery – in fact, she could not bear to think about it, coping with its terrors by shutting it out of her mind.

Two more baby boys were born at Hale End, Barclay and Richard. Although Favell loved them dearly she was not as close to them when she was young as she was to Robert, who, like her, was, in a quiet way, to prove a great force for good in society when he grew up.

We have already seen that Favell lost three of her maternal uncles in her early childhood. The fourth, Richard Lee, she probably saw infrequently although, during her childhood, he lived near the Bevans' old home in York Place and shared business interests with David Bevan. Towards the end of his life he lived in Tunbridge Wells with his "companion" Charlotte. But if Favell lacked uncles on one side of the family, there were frequent visits from uncles on the other side. Uncle George Bevan, who died when she was only seventeen, was a frequent visitor to Hale End. He expressed disapproval of the children's games of imagination and invention, perhaps seeing them as theatrical play-acting in embryo. He disapproved also of Dr Collison – at first.[23] Poor Mrs Bevan found his violent opposition to Dr Collison's teaching upsetting and decided she would not speak to him again on the subject. However, great was her surprise and delight when on his next visit he announced that he had changed his views completely and now agreed with Dr Collison's ideas! Just which doctrines were in dispute is not clear. Perhaps it was Dr Collison's eagerness to work with genuine Christians of all denominations that upset him at first. George was not the only uncle to influence the family

in general and Favell in particular. Contact with Uncle Frederick, Uncle Richard (Bevan) and Uncle Charles all played a part.

Louisa followed her mother's example and set aside an hour each day for reading the Bible and praying in her own room. Favell also experimented with this but soon found it irksome, lacking Louisa's true change of heart, and gave it up. As she grew she became frustrated by the family's narrow circle and longed for more friends. But Hale End could provide little in the way of company for her. Mrs Bevan tried to make up for this, doing all in her power to provide amusement for the children to compensate for the lack of other company. The girls grew older and masters were engaged to teach them various academic subjects. Dr Collison introduced them to an art expert, a Mr John Dennis (b.1750), who taught them art by meeting them at the Royal Academy of Arts Exhibition. Here he used the pictures on display to teach them the principles of painting.

Mr Dennis's daughter, Maria, became Favell's lifelong friend.[24] Both Mrs Bevan and Louisa took up drawing and painting as a result of association with the Dennis family and Louisa also became interested in botany and mineralogy – both fashionable hobbies for young ladies. But Favell was not interested in these pursuits, preferring instead to read. Works of fiction had not been encouraged when the girls were young. Things were different now and for the first time they read the novels of Walter Scott. They were fascinated and were soon devouring all the fiction they could lay their hands on.

Although there was a lack of suitable young companions for the Bevan girls, there was one family of neighbours with youngsters nearby. This was the family of a solicitor, a widower who lived with his four daughters. The eldest daughter was a devoted Christian young lady who delighted in helping the poor locally and visiting the sick. She ran the household for her father and cared for her sisters. This young lady seems to have befriended Louisa, Favell and Frederica and one can guess that Lousia, at any rate, would have enjoyed her company. Sadly, however, there seems to have been some friction in the household and the solicitor's other daughters complained about their elder sister's

retiring and self-denying attitude, finding it restricting. This situation had a very negative effect on Mrs Bevan as she watched the difficulties unfold. She decided that it would be a mistake to make unconverted children fully conform to the restrictions of a godly life-style (as this young lady was trying to do) and made plans for a startling change in her own family's way of life.

By this time the young Bevan girls were already conducting their own school among the village children. This may seem remarkable to us today, but when Favell was a teenager *ad hoc* schooling conducted as a charitable exercise was not unusual. Theirs was a Saturday school and for a venue they commandeered the laundry which was presumably an out-house attached or near to the house itself. The children's interest was kept up by the provision of rewards of bonnets and tippets[25] – from which one gathers that the pupils were only or mostly girls. The little pupils were also given tea or even dinner and the girls visited them in their cottage homes. This was Favell's first experience of something that was to form a great part of her life's work and she seems to have entered into it with zest even at this stage. Religious instruction would certainly have formed a major part of the little school's curriculum. Sadly, of the three girls it was only Louisa who could have explained to the village children anything of the gospel from personal experience.

Although Favell might have sighed for the company of other young people, she did enjoy visits from family members like Uncle George and other close friends. Her father now chaired meetings of the British and Foreign Bible Society and was Treasurer of its City of London Auxiliary.[26] The girls became enthusiastic collectors for the Society and when speakers came to address local meetings they were entertained at Hale End. Bible Society speakers often had a fascinating fund of stories from around the world but this, mind-broadening as it must have been, was not enough to satisfy Favell and she still pined for young company.

Another baby arrived when Favell was sixteen, Francis, named after her mother's sister. Favell adored the little girl and acted as her nurse. But her longing to mix in a wider society did not

diminish and she was not happy. In fact, on her sixteenth birthday she cried bitterly. She felt totally unprepared by her sheltered life for the responsibilities of adulthood and she was becoming painfully aware of a world of gaiety and life beyond her narrow circle. ·Why wasn't she allowed to taste its delights?

There was indeed a life to be lived beyond the restrictions of evangelicalism – especially if one was sufficiently wealthy. One only has to read Jane Austen, whose novels were published at around this time, to gain a picture of what it was like. What Austen depicts is a society so godless that religion (as opposed to the church) is not even considered a proper topic for polite conversation. In Austen's world, the poor are either so utterly disregarded that they might as well not exist, or at best form a kind of useful adjunct to social life by being available to be graciously helped. Balls, assemblies, card parties and hunting fill up the daily round of life. The best of her characters espouse a kind of Kantian[27] duty-based morality and one cannot for a moment imagine any of them seriously pondering on the eternal state of their soul or coming to Christ for forgiveness and pardon. The contrast with the Bible-centred life of the Bevan family at Hale End is marked.

It is their marriage prospects that fill the horizons of Austen's young female characters and it may well have been her own limited prospects in this direction that made Favell tearful on her birthday. Her father was rich: that would have counted in Jane Austen's world. But how was she ever to meet with anyone suitable? As far as is known at this time, the Bevans were still attending Marsh Street Independent Chapel in Walthamstow. Did the congregation there consist mainly of local tradesmen and their families? If so, such a circle as Marsh Street provided may well have seemed to present no marriage prospects at all to the young, and still unconverted, Favell.

Mrs Bevan, meanwhile, was also probably worried on the same score. Her husband, though fond of Louisa particularly, seems not to have taken much part in the up-bringing of his children. One of his granddaughters wrote that he "...seemed to have very little

control over his sons..." instancing the fact that Robert was allowed at the age of seventeen to "...take himself away from school and spend a year enjoying himself in London and the hunting field."[28] Certainly it seems to have been Mrs Bevan who made the crucial decision to make a change in the girls' upbringing.

Watching the difficulties of the solicitor's family with whom they were friendly she came up with her own surprising – even startling – solution: she engaged a daily dancing master.

Previously Mrs Bevan had been very concerned about worldliness in her girls. One Sunday when they were small they had been so delighted with the little wreaths of flowers round their hats that she removed them while they were in their carriage on the way to Marsh Street Chapel. Now she swung to the opposite extreme and allowed them pleasures far less innocent than flowery hats. She justified her decision by claiming that it would be a mistake to "...make the unconverted conform to religious observances..."[29] and that she should, though having no taste herself for worldly amusements, "...make allowance for young people as having different tastes..."[30] However, if this was really her only reason, it is difficult to understand why she forced this change on Louisa who was not unconverted and who, far from having a taste for dancing, remonstrated with her mother and begged to be excused from the lessons. It would seem in reality that Favell and perhaps Frederica wished to learn to dance. Mrs Bevan, therefore, was afraid of creating the very situation she strove to avoid and which she witnessed in the local solicitor's family. She did not want difficulties and disharmony between the sisters to result from the eldest being a believer and the younger sisters unbelievers. She must also have considered that being able to attend balls would widen the girls' social outlook. It would also enable them to enter a setting in which eligible young men could be found. Herein was the difficulty which she seems to have ignored for, in the context of a ball, Louisa would almost inevitably come under pressure to accept a match with an unconverted man. Her protests were swept aside. She was told that she must learn to dance because, "it would not recommend religion, if she were more awkward than her sisters."[31]

Marian Farmer, now a godly young woman, is not mentioned in connection with the dancing lessons. Was she already earning her own precarious living as a governess? Was she, like Fanny in Jane Austen's *Mansfield Park,* not considered to need such experience as balls and assemblies? If so, she was probably as grateful to be excluded as at first Fanny was.

What about Dr Collison? One imagines that his views would have been similar to those expressed around this time in a popular printed sermon *Fashionable Amusements the Bane of Youth* by John Morrison[32] which dealt with the whole subject in a way that could leave readers in no doubt. Perhaps the relationship between the Bevans and their once respected minister began to grow cold at this time.

Mrs Bevan did receive at least one warning about the course of action she was taking. One of Favell's uncles, Frederick Bevan (1779-1859), wrote to her, "Beware, you are putting your foot in a stream, the force of which will carry you away... "[33] His warning went unheeded: Mrs Bevan was convinced that her careful Christian education of the girls would be proof against all dangers.

The dances of the day were complex, difficult and exhausting and required a great deal of practice to master. There was also an exacting code of behaviour at a ball which must be followed to the letter. Such things were taught to girls of Favell's station as a matter of course, even if the rest of their education was completely neglected, and the Bevan girls would have to work hard if they were to catch up. But the girls made progress and eventually were invited to a ball. "[A] ball is the ultimate occasion for a heady kind of courtship – a trying out of partners that is exciting, flirtatious and downright erotic,"[34] explains one authority: no wonder evangelicals avoided them! Louisa did not want to go but was made to accept along with the others. They all enjoyed themselves immensely, returning home as was the custom in the small hours. Louisa tried to carry on her daily devotions, reading Dodderidge[35] before breakfast as usual, but it must have been difficult. Their mother next took them to an assembly in nearby Woodford. Whereas a ball was held in a private house and the guests were

invited, an assembly was run on similar principles but in public assembly rooms. Admission was by means of tickets which were for sale. At first, the girls were accepted and welcomed at the assembly by their neighbours. But they were now being plunged into an environment for which they had not been truly prepared: success in this worldly atmosphere could not be attained by suddenly taking dancing lessons. Jane Austen would have surely exercised her wit at the expense of these gauche girls from the despised Independent Chapel for whom the most exciting event in the social calendar was a Bible Society meeting.

Pretty young Louisa's objections to the new way of life melted away as she began to enjoy herself. Favell and Frederica thoroughly enjoyed the changed atmosphere. The next thing was to give the girls a London "season" where they could attend all the amusements on offer and display themselves to good effect to prospective suitors. David Bevan, accordingly, purchased a house in Upper Harley Street so that they could reside in town whenever they wished. Once on show in this new milieu there is evidence that the girls were snubbed in exactly the way some of Jane Austen's less likeable characters snubbed others in their circle. To such sophisticates, they must have seemed like uneducated bumpkins, never attending the theatre or the opera, but spending their time instead collecting for the Bible Society and teaching poor children in the family laundry. They had no connections with fashionable society and must have appeared to those who encountered them as if they had no topical or up-to-date conversation. This was felt more keenly by Favell's mother than by the girls themselves. They only pined to leave the narrow circle of Walthamstow completely, seeing it now as isolated and boring.

In fact, the family was not to remain at Hale End and the Marsh Street Chapel for much longer. David Bevan was looking round for a larger, grander house altogether. He found exactly what he wanted at Belmont, East Barnet, just far enough away to be out of the reach of the scholarly and narrow-minded Dr Collison.

Endnotes

[1]Meyer p. 155.

[2]See for instance Dalton, Russell W., *Children's Bibles in America,* (London and New York, 2016) p. 72.

[3]The subtitle of *The Peep of Day,* (London, 1833).

[4]Meyer, Louisa Clara, *The Author of the Peep of Day,* (London, 1901) p.*v.*

[5]Pruzan, Todd, *The Clumsiest People in Europe,* (New York, 2005)

[6]Constable, Rosalind (Mrs Mortimer's great-niece) writing in *The New Yorker* 1950

[7]Meyer p.*v.*

[8]Favell Bourke Bevan neé Lee (1780-1841)

[9]Rather like a modern-day solicitor.

[10]That is she had white father and a black mother.

[11]Information about racial ancestry supplied by Anne Powers (http://aparcelofribbons.co.uk/) who has studied the subject.

[12]Anne Powers, private communication.

[13]A verdict of insanity was often given when there was a suicide as it enabled the body to be buried in consecrated ground. This was otherwise not allowed for suicides.

[14]Robert's hypochondria was typical of the late stages of general paresis, a mental condition caused by syphilis.

[15]Marian's situation is reminiscent of Fanny in Jane Austen's *Mansfield Park* or Harriet Smith in *Emma* and was probably a common circumstance at the time.

[16]Despite the difficulties, Favell and the unfortunate Marian were lifelong friends, but there is no hint in any of the surviving accessible material that suggests Favell *ever* knew that they were cousins. This impression may be due to the natural reluctance of her early biographer, her niece, Louisa Clara Meyer to point this out.

[17]A group of evangelicals within the Church of England famous also for their active opposition to the slave trade.

[18]Meyer p.3

[19]Meyer p.3

[20]William Jay in his *Reminiscences* mentions an incident relating to Mr Collison that is strikingly similar but concerns a Mrs Smith, a convert of Jay's at Bath

who lived in Woodford near Walthamstow, not Mrs Bevan. Either Collison had a talent for the recruitment of wealthy ladies *via* their servants or Jay has somehow confused two different incidents. See William Jay, *Autobiography* p. 442 in the Banner of Truth Edition.

[21]See Chapter 8.

[22]Meyer p. 9.

[23]George Bevan was involved in a group of Anglican vicars including James Harrington Evans (1785-1849) who became Baptists and left the Church of England – the so-called "Western Schism." They then slid into seriously unorthodox views of the Trinity. Harrington Evans realised his mistake and repented of the error, writing a book to refute his previous views. By this time, George Bevan was already dead but one suspects, seeing how prepared he was to change his mind on other issues, that had he lived he would have followed Harrington Evans' example.

[24]See Chapter 10.

[25]Small capes.

[26]An Auxiliary was a local group of supporters. Most Christian societies and organisations of this period operated by means of such auxiliaries which raised funds, organised meetings and recruited members.

[27]Immanuel Kant (1724-1804) was a philosopher who argued that in order to act in a morally correct way one must act purely in accordance with one's duty.

[28]Webster, Nesta, *Spacious Days,* (London, 1949) p.13

[29]Meyer p.11

[30]Meyer p.13

[31]Meyer p.13

[32]Preached in 1824 at Ranelagh Chapel, Chelsea and then published.

[33]Meyer p.14

[34]Mullan, John, "The Novel 1780-1832" http://www.bl.uk/romantics-and-victorians/articles/the-ball-in-the-novels-of-jane-austen Accessed 10/05/16.

[35]Probably his enduringly popular *Rise and Progress of the Soul,* (1745)

Chapter Two (1826-1830)
Belmont

Favell was twenty-four years old when her father purchased Belmont House. It was a considerable step up from Hale End. At last David Bevan owned a luxurious country home, dating back to the sixteenth century. Surrounded by rich pastures, Belmont was set in extensive grounds and boasted a beautiful grove of trees, all laid out with walks and summer-houses. Parts of the house had been planned by Inigo Jones, but it had been much altered and extended since its original construction and now represented the height of comfort and elegance.

The house had an entrance hall floored with beautiful pure white stone and David Bevan lost no time in filling this space with a collection of pictures and busts, turning it into almost a private art gallery. He turned to John Dennis to advise him on his purchases and as a result his collection included works by fashionable and influential artists such as the French landscape painter Claude le Lorraine (1600-1682) and classicist Nicolas Poussin (1594-1665). These painters were much admired in England at the time and greatly sought after by collectors. To complement this fashionable picture collection, he filled his house with the best French furniture.

The family continued to try to insinuate itself into polite society. There were trips to Paris where performances by the fashionable French actor François Joseph Talma (1763-1826) were enjoyed. Now no one seems to have batted an eyelid at attending the opera and the theatre when they were staying at their Harley Street home. The girls still failed to shine in society, however, for which failure they seem to have blamed their mother's narrow

educational provision. Favell continued to devour reading matter at a prodigious rate and a trace of their old way of life lingered in that she enjoyed teaching little Francis history and Bible stories. But she was not happy and in spite of it all there was no eligible young man in the picture. She might as well have remained at Marsh Street!

But, if Favell did not find a husband as a result of this entry into society, Louisa did. In 1825, she married Augustus Bosanquet. That he was a pleasant enough young man seems not in doubt: that he was not a Christian at the time is certain. At first the young couple seem to have resided at Belmont. Later Favell's father bought a house at nearby Osidge for them.[36]

As Favell walked in the pleasant Belmont garden one Sunday morning with her sister and her new brother-in-law, the conversation turned to the question of how one can be saved. Louisa and Favell at once said that salvation was by faith. How could pupils of Miss Clare, raised on the Shorter Catechism under Dr Collison's direction from early childhood, have said anything else? Mr Bosanquet disagreed. He believed, he said, in good works. These, he thought, were made effectual by the Saviour's atonement.

Surprised that she could not refute the arguments her brother-in-law offered, Favell set herself the task of examining all that she had been taught on this subject as a child. "She entered on a thorough examination of the Truth having previously resolved that to whatever issue she brought it, she would abide by her convictions however great the sacrifice demanded of her."[37] As she reviewed all the old teaching on sin, repentance and holiness of life, she became dissatisfied – not with the teaching but with her life. There was a painful clash between what she had been taught, which she felt deep in her heart to be true, and the social life she now lived. At first, she would return from balls at three in the morning and try to come to terms with her conscience by reading the works of Archbishop Leighton (1611-1684) before going to bed. Leighton was a Scot best known for his commentary on *The First Epistle of Peter* and Favell would have found absolutely no

encouragement to continue with "revellings" and "banquetings" in his comments on the fourth chapter of that epistle. Those who "walk in these high ways of impiety and yet will have the name of Christians, they are the shame of Christians, and the profest enemies of Jesus Christ, and of all others most hateful to Him, that seem to have taken on His name for no other end, but to shame and disgrace it..." he explains sternly.[38]

While all this was going on, Favell threw herself with enthusiasm into her old employment of teaching village children. Now, however, it was not a case of gathering the local girls into the wash house on a Saturday. There was a village school nearby and Favell went there, probably daily, to teach the children "Scripture History." There is more than one significance in this phrase. Favell was still in no state to teach the children "Scripture Doctrine" or even the simple way of salvation. The plain events of the Scripture narrative, the history, were all she was capable of passing on. But later, when she knew the Lord for herself and had a passion for the souls of those she instructed, it was through the *narratives* of Scripture that she was enabled to make known the saving truths that all children – and adults – need to understand.

Meanwhile Favell's married sister, Louisa, was undergoing a crisis. Her first child was born at Belmont: a daughter named Clara[39] after their old governess, Miss Clare. After the birth, Louisa suffered from what would now be diagnosed as post-natal depression. Although she felt a little better when her kind and attentive husband was with her, she was weighed down with sorrow. What grieved her most was the thought that her baby had been born into a world where every luxury would be provided, but her deepest need would remain unfulfilled. Louisa went through anguish of heart as the realisation hit her that she had lost her first love and had departed from following her Lord. Although remote from all spiritual help and advice, she cried to the Lord for forgiveness and He graciously heard her cry.

That summer, the sisters were living in the same house and spent a good deal of time together, but Louisa kept this experience to herself. This is understandable. She had been led astray by the

mistaken judgment of her godly mother and lack of guidance by her father. She was, in effect, repenting for having married her cheerful and kind husband. How could she tell them without implying a reproach to them all for what had happened?

But Louisa's problems were eclipsed by a new development which, although sad, was to have a very happy outcome for Favell and in some ways for the whole family. Their father, now fifty-six years old, seemed ready to settle down and enjoy the magnificent home he had put together at Belmont. But he had been there less than three years when he suffered a series of strokes which left him partly paralysed, affected his speech and made him confused. He could no longer enjoy his magnificent grounds, his picture collection and his grand house. Mrs Bevan was devastated. The medical men pronounced the case hopeless and she faced the prospect of losing him.

David and his wife seem to have had a cold relationship up to this point. Now everything changed. Mrs Bevan's "...affectionate heart reproached her with a thousand omissions."[40] She prayed fervently that her husband's life might be prolonged at the same time waiting on him night and day with a tender devotion that had probably not been typical of their relationship before. The girls also were deeply moved and grew closer to their father as they helped to nurse him. The whole family was united. Robert, who was at Oxford, came home to help his father who now could not even move from his chair. Silent and prayerful, they surrounded the sick man, hardly daring to hope that he would be spared and communicating with him only with difficulty.

Throughout this crisis there was a work of grace going on in Favell's heart softening and preparing it, she later said, "to receive the seed of God's word."[41] Her father's illness was a stern reminder that worldly pleasures wither away. She longed to be able to comfort her mother in this awful trouble, but she could not. She did not herself "know the source of true comfort."[42] Now conscious that religion was vitally important, she began the practice of evening Bible reading with her brother Robert.

Favell's mother's prayer was answered. She was allowed an extension of time in which to show her devotion to her husband: slowly he began to improve. Her prayers for Favell were soon to be answered too.

Treatment for cases of paralysis (and indeed for almost every illness) at this time often included moving the patient to the coast for a "change of air." On the doctors' advice, when Mr Bevan's condition seemed to have stabilized, the family went to Hastings for five weeks. Here they stayed near Favell's Uncle Frederick Bevan who, it will be remembered, had sounded a warning voice over the whole issue of dancing and balls. He visited the family every day and took Favell to hear the preaching of Rev Dr Devey Fearon (1769-1847), rector of the nearby village of Ore. Dr Fearon was an evangelical, associated with Charles Simeon of Cambridge[43] and his may have been the first evangelical preaching Favell had heard since leaving Hale End. Under his ministry Favell found the peace that she longed for. "'I have not known rest in the world,' she said to herself, 'but it is promised to me in God, and there will I seek it.'"[44] She now realised that she had only considered her own happiness in earthly terms, living out her life for her own benefit and not for God's glory.

Favell spoke to her Uncle Frederick about her feelings and he told her, "You know you must renounce the world. 'Come out from among them and be ye separate.'" She replied that renouncing the world seemed to her a very little thing, if by the world he meant gaiety and amusement.[45] Later she was to say of this period of her life, "At my conversion, I felt as one who has seen the bursting of the bubble which he was pursuing. The labour of the world in general is as vain as it would be to write without ink, or [do needle]work without a thread."[46]

Favell's repentance and dedication of her life to the service of her Saviour was a great comfort to Mrs Bevan. Another reason for her husband's illness in the workings of Providence could now be seen. The patient continued to improve in health and the spirits of the whole family rose. They all went to hear Dr Fearon whose practical and spiritual preaching benefitted them all.

From Hastings the family moved to Brighton where David Bevan's health improved still more. At this time Favell's paternal grandparents, Sylvanus and Louisa Bevan, were living in Brighton as were their youngest son, Favell's Uncle Richard, and his wife, Charlotte. Uncle Richard was a banker like his brother David and he took Favell out riding on the downs which must have provided welcome exercise and refreshment. Favell continued to grow as a Christian, finding much blessing in reading the Psalms. Unable to trust her own heart, she was encourage to read how David, "when surrounded by temptations, thirsted after God," and she "felt that the same God could inspire her with faith, could enable her to devote to His service all that remained to her of life, and could empower her as His gift to believe habitually and really in the love of Christ."[47] But the thing that came home to her with force that will most encourage modern readers (especially parents) was the instruction of her youth. Miss Clare, Dr Collison, her mother's daily teaching, all of it, "now proved invaluable, invested with the attractions of novelty and yet with the familiarity of long use."[48] She had known it all along in her head; now it flooded her heart with joy. She looked around at once for others to teach (this was to be the pattern of her life) and immediately began instructing the nearest person available, her personal maid, in the truth of the gospel.

The family now attended the popular St Mary's Chapel in Brighton which belonged to Wilberforce's friend, Charles Elliot (1752-1832) who had retired to Brighton from Clapham. This chapel was an elegant Greek revival design building and the chaplain was Elliot's son, Rev Henry Venn Elliot (1792-1865) who welcomed Favell and enabled her to teach in the Sunday School. Her new-found faith also gave fresh impetus to her letter writing and sick visiting. Her relationship with her cousin Marian Farmer, (now a saintly and devoted Christian governess) also seems to have deepened at this time. Now the girls, who had probably grown up in each other's company at least in the school holidays, were not just friends. "To be a friend of the soul made friendship itself appear in a new light."[49]

By the end of July 1827 David Bevan was so much improved in

health that the family moved back to Belmont. He was not able, however, to take up his old post at Barclay's bank. Favell's brother Robert took his place, never returning to Oxford.

Favell was home again, but her life had changed completely. Every day she spent time going out visiting the poor and sick and teaching in the local schools. There being no gospel preaching in the area, Favell's witness to the schoolchildren was particularly vital. For most of them it must have been their only opportunity of hearing clearly the way of salvation.

At home Favell threw herself into studying the Scriptures, not only in private but also with her mother. Once she had considered God as a task-master and longed to banish Him from her mind. Now she was full of gratitude to her Saviour, happy in the work set before her at Belmont. She no longer felt any need for the gaiety of London balls and theatres and presumably her mother had long since ceased to desire this atmosphere for her girls. Favell made new friends too. Not far from Belmont was Copped Hall, Totteridge, once the home of the young Henry Manning, a school friend of Favell's brother Robert. When the Mannings moved, the house was sold to the Hall family and it was young Miss Mary Hall who became Favell's friend. Mary was the eldest of a large brood of children and she seems to have been an enthusiastic and outspoken Christian, witnessing for her Saviour wherever she went. The girls were to remain friends until Mary's death in 1841. Other girls working in the schools and in hospital visiting alongside Favell were Miss Helen Johnstone and Miss Matilda Bowles and they became firm friends. Matilda had been converted some years previously under the preaching of Dean M'Neile. The dean was to be a great influence in Favell's life: right down to her old age she regarded him as something of a hero.[50] These friendships were lifelong and a mutual blessing. Here was the beginning of the wider social life that Favell had longed for when at Hale End. "Gaiety and amusement" had failed to provide the company she wanted, but a heart relationship with Christ had opened up a whole new world.

It was not only the Bevan family which rejoiced in a new gospel

light. The practical infidelity that strangled the Church of England and Dissent alike during the so-called Age of Enlightenment was at this time giving way to the Evangelical Revival. This had begun powerfully with Whitfield and the Wesleys, and continued with Wilberforce's many schemes until London was awash with sound preaching. Carriage after fashionable carriage now dropped its occupants at the doors of St John's Bedford Row, the Surrey Chapel, the Episcopal Chapel in Longacre and the Percy Chapel, to name only some of the most popular places of worship. Many lesser figures such as Basil Woodd, still ministering in Marylebone, drew large congregations. Some modern commentators, at a loss to explain the phenomenon, imagine that sermons were popular because pulpit oratory was the only entertainment available on a Sunday, but this would hardly explain the associated vogue for printed sermons and Christian magazines of all types!

Some of the preachers were highly respectable such as The Reverend The Honourable Baptist Wriothesley Noel (1798-1873) at St John's, Bedford Row who was later to leave the Church of England and join the Baptists. Others were more eccentric or quaint. Old Rowland Hill (1744-1833) of the Surrey Chapel, for instance, when preaching to sailors at St. John's Wapping quipped that he had "...come to preach to great sinners, notorious sinners, profane sinners, *wapping* sinners." Just as witty was William Howels (1778-1832) of Longacre, a characterful Welshman. Howels was famous in his native country for preaching in Welsh wherever he could gain a hearing even in non-conformist chapels or in the open air. When reprimanded at last by his Bishop for preaching on unconsecrated ground, he replied, "I have never so done; when the Son of Man set foot on this earth He consecrated every inch of it; if not, I am afraid no consecration of Your Lordship's will do it any good."

But if there was vigorous growth in Christian life, not all was necessarily healthy. The church was flourishing, but there were also some weeds among the crop and at the time they were difficult to see. Evangelicals were distressed by ignorant, indifferent clergy who neglected their duties and by the masses of workers crowding into the new industrial towns without religion of any

sort. There were others who found these things worrying too and seemed to share with Evangelicals a desire for a more "spiritual" national church. Those who eventually formed the Tractarian movement, or Catholicising wing of the Church of England were at first mixed almost indistinguishably with Evangelicals, having objectives which seemed similar and which could be confused.[51] Both deplored the situation, so well described in the novels of Jane Austen, where church livings were just that: a means to an income which could be bought and sold or distributed to family members while a poor curate was paid very little to do the actual work. Communion services were infrequent (this angered the Tractarians) and there was little gospel preaching (this angered Evangelicals.) Both groups had more in common with each other than with those who favoured the *status quo*. Both groups consisted of men who actually believed something, although, as it turned out, it was not the same thing.

Another departure from orthodoxy in a different direction involved Favell's Uncle George[52] as already described. Then there was Favell's life-long hero, Dean Hugh M'Neile (1795-1897), the big hearted champion of orthodox Protestantism. He was initially associated with the bizarre, theatrically Pentecostal and eventually theologically unsound Edward Irving (1792-1834) who in the end descended into errors over the Trinity not unlike those of Favell's Uncle George. At the time, it was difficult to see where all these confused and tangled threads were leading. It is only with hindsight that the situation becomes more distinct and clear.

It is worth looking over Favell's shoulder at this period after her conversion to see what she was reading. Favourites were sermons and commentaries by Thomas Scott (1747-1821) and Richard Cecil (1748-1810). Both these men were Church of England clergymen. Scott was converted after having already been a minister for some years through his own reading and through the influence of John Newton (1725-1807). Cecil was an associate of Wilberforce's. It was he who, years earlier, had preached an arresting sermon heard by Favell's mother before she was converted herself.[53] Favell also recorded as helpful the sermons and letters of the evangelist George Whitfield (1714-1770). Whitfield, a generation before, had

been used of God to spearhead the eighteenth century revival that in turn sparked the various movements in the early nineteenth century. An ordained Church of England minister all his life, Whitfield had yet maintained a warm relationship with dissenters such as Philip Dodderidge and Isaac Watts as well as working alongside the Wesleys despite their theological differences.[54] Among contemporary writings Favell devoured those of Edward Irving[55] on *Infidelity* and *Babylon* and was so impressed with his advocacy of the literal fulfilment of prophecies and the restoration of the Jews that she went to hear him preach. His appearance struck her as wild and his gestures as strange, but at the time he pleased her imagination.

There was no gospel ministry in the Belmont area. The family still had their town house in Harley Street, however, and when in town they went to hear Baptist Noel at St John's Bedford Row. Favell also heard Rowland Hill preach. Most influential of all on the family, however, was the preaching of William Howels. The whole family including the servants and the Bosanquets (Favell's sister Louisa's family) attended his Episcopal Chapel, Longacre, and were much benefitted. Louisa's husband Augustus Bosanquet was particularly helped, and it seems he was converted under Howels' ministry. What an answer to Louisa's prayers this was!

In June 1830, Favell's wrote to her friend Matilda Bowles describing an incident that occurred while she was walking near Belmont. It was the first of many that were to characterize Favell's whole life. She wrote:

"I met a beggar girl, who told such a history of herself, and who appeared so well behaved, that I adopted her, and placed her with Sally Harris, whom I visited at the doctor's request, and who is now recovered. The girl's name is Louisa Achsel; she is fourteen, I teach her daily, and she goes to school. Her father was a German umbrella maker, and travelled in a caravan with Louisa and her sister Tracey. He was a good man, though not enlightened, and often talked to Louisa of the Saviour. He died at Barnet two years ago, and his property, £50, was claimed by the children's stepmother, who took them about with her from place

to place hawking nets and matches. Louisa she treated cruelly and finally turned [her] out penniless. The poor girl begged her way back to Barnet, where she was received by a tinker and his wife, friends of her father. She had been with them four months, hoping for a situation, and begging by day. Her ruin seemed certain. Her willingness to give up her liberty and submit to guidance promised well."

Louisa was the first of Favell's many adoptees. She tracked down her sister Tracey at Brentford and she too was taken under Favell's wing. Both girls were saved from the kind of trafficking that endangered them and Louisa went on to have a very long and interesting life thanks to Favell's intervention. She kept in touch with her benefactress for many years.[56]

Endnotes

[36]This beautiful house still stands and is now the Sir Thomas Lipton Residential Care Home.

[37]Gamble pp.105-6.

[38]Leighton, Robert, *A Practical Commentary upon the First Epistle General of St. Peter*. Vol. II, (London,1694) p.270

[39]Meyer p.18

[40]Meyer p.19

[41]Meyer p.19

[42]Meyer p.20

[43]Simeon (1739-1836) was an influential Evangelical whose example and teaching at Cambridge ensured that a stream of young Evangelical clergy was fed into the Church of England. He crops up over and over again as the inspiration and guiding force behind many of Favell's friends and associates. See Prime, Derek, *Charles Simeon,* (Leominster, 2011).

[44]Meyer p.20

[45]Meyer p.21

[46]Meyer p.67-8

[47]Meyer p.22

[48]Meyer p.22

[49]Meyer p.23

[50]See below and Chapters 4, 6, 7, 8, and 10.

[51]Many of the prominent Tractarians who became Roman Catholics were children of Evangelicals.

[52]See below.

[53]See Chapter 1 Footnote 21.

[54]See Dallimore, Arnold, *George Whitefield,* (Edinburgh, 1980)

[55]See above.

[56]See Chapter 5.

Chapter Three (1830-1833)
Fosbury

Favell placed Louisa Aschel in service at Fosbury, in the wilds of Wiltshire. This tiny hamlet, miles from anywhere, was the site of Grandfather Sylvanus Bevan's country estate. Sylvanus chose the spot for its peace and quiet and the house he built, or possibly adapted from a former building, still stands today. A stone portico adds an air of grandeur to the house (small by Belmont standards) which was surrounded with a paved walk where Grandmother Louisa Bevan would take her daily constitutional. The situation of the house was so lonely that the old lady seems to have found it a little depressing, but Favell loved the place. Old Grandmother Bevan had been reduced to providing scarlet cloaks for the local school children so that she could see some colour as they crossed the park to and from school, but Favell needed no procession of artificial robins to brighten up Fosbury for her. She called it a "paradise beyond expression."[57] She was (like her brothers) an excellent horse-rider and she found the freedom of riding unescorted over the downs exhilarating.

But it is not only the house that is still standing. Not far from the gates that lead to the drive of Fosbury House is a building, now converted to other uses, which Sylvanus Bevan built as a schoolroom. Landowners as a rule staunchly supported the Church of England, considering this pillar of society to be as essential to the stability of the country as the legal system, parliament or the crown itself. Non-conformity was sometimes regarded a threat to the established order. But Sylvanus was not a typical nineteenth century country squire; he actively funded at least one independent meeting house in the area and he had

never totally lost touch with his Quaker roots. Because Fosbury at that time had no parish church, Sylvanus's schoolhouse was used for church services where his son, Favell's Uncle George Bevan, occasionally preached. There seems to have been a small revival in Fosbury as a result.

One of those converted under Uncle George's ministry at Fosbury was a cottager named Lizzie Barlow. Lizzie lived with her friend Betty close to the schoolroom, probably in one of the row of cottages that is still standing almost opposite the Fosbury House gates. "[S]uch an old fashioned cottage, with an open chimney corner, a kettle or pot hanging over the small iron dogs which served as a grate, a wooden dresser and bench, all in keeping with red cloaks and black bonnets."[58] Old Lizzie and Betty were a complete social contrast to Favell's young Belmont friends, Helen Johnstone or Matilda Bowles, but they too became two of Favell's dearest associates. Another Fosbury character was the labourer known only as "Old William," also probably converted under Uncle George's ministry. William, in turn, witnessed the softening of his grumpy and unbelieving wife, who was so surprised when he returned her unkindness by fetching her water from the pump that she was moved to repent and turn to her husband's Saviour. Down to old age William told the gospel message to the villagers. When he was no longer able to walk, he rode from house to house on a donkey.

At Fosbury, another good friend to Favell was the gamekeeper's wife Mrs Farr. Orphaned when young, Mrs Farr had been brought up by her relations. Her grandfather's example of prayer had impressed her as a child, but it was not until she came to Fosbury as Benjamin Farr's bride that she came to know the Saviour for herself. "I never knew anyone delight more in God, and yet be so little in her own eyes," wrote Favell, "This self-annihilation seems the distinctive mark of a right spirit." Mrs Farr suffered the loss of several of her children and the grief this brought, "taught her to live a life of constant prayer."[59] She spared no pains in training up her surviving children, of whom at least one, Sarah, was of help to Favell in the establishment of the Fosbury school. When she became ill and unable to walk from cottage to cottage or to the

schoolroom to bring the comfort of the gospel to her neighbours, Mrs Farr continued her work by riding a donkey round the village just as Old William had done. Favell missed her greatly when she died in 1834 at the age of fifty-one. Favell was able to see her just before she died and found her overflowing with gratitude for the blessings she had received from the Lord at Fosbury.

These humble people were Favell's close friends although they were only her grandfather's tenants and estate workers. They must have formed a refreshing contrast to the fashionable and wealthy set who had snubbed Favell when she and her sisters tried to become part of London's worldly milieu.

Fosbury might have been a haven of peace and tranquillity, but it was not immune from the troubles of everyday life. In the year of Louisa Achsel's rescue and adoption, the nation was rocked by the so-called "Swing Riots". Poor farm labourers all over the country were facing a desperate winter. In the lean months they had been accustomed to earn money threshing grain by hand. The newly-invented threshing machines took over this work. Riots and machine breaking occurred in many places as the men, led by the mysterious Captain Swing, tried to get some improvement in their conditions. Harsh measures were used to contain the situation and in Wiltshire the yeomanry were called out. Convicted rioters were transported to Australia. At Andover not far from Fosbury, the situation was very serious and gangs of men smashed up Tasker's ironworks where metal parts for the threshing machines were made. In November, the dreaded winter months were approaching fast and at Vernon Dean, about two miles from Fosbury, the desperate rioters broke up the hated threshing machines and other farm equipment. The next day, they marched up the drive of Fosbury House itself, asking for a signature to their list of grievances. One of the tactics of the Swing rioters was to try to enlist the help of large landlords in this way and some of the pathetic and respectful requests for work and wages still survive:

Our complaint is that we have not a suficent maintance to suport our famleys, and as theare a geving more wages in

the joining Parishes we do request that you will consent and sine your hands to this paper...[60]

Who was it that met this menacing crowd of two hundred hungry men, persuaded them not to burn ricks and smash ploughs, signed their "paper" and gave them refreshments? David Bevan would presumably be too ill and Sylvanus probably too old. Perhaps it was the young Robert Bevan giving an early demonstration of his skill in the handling of a threatening crowd.[61] Whoever he was, he did the job very well. The men promised to break nothing that did not directly interfere with their labour (i.e. only the threshing machines) and left cheering loyally "Bevan forever!" At another house nearby they had met with a less pleasant reception: the occupants resorted to firearms to scare the mob away.

Sadly, it was not long before a terrible vengeance was taken on the rioters. The yeomanry arrived at Fosbury with orders to ensure an exemplary punishment. Fifty Fosbury men were captured as the soldiers chased them over fields and dragged them away from their wives and children, forcing open cottage doors while the men tried to hide in hen coops or outbuildings. The yeomen had no time to be particular whom they apprehended. Innocent men were captured along with the guilty and had to prove that they had not taken part. The attempt to get better conditions had made matters worse than ever. Alas for the rioters! The winter of 1830 was long, freezing cold and snowy all over the country with icebergs in the Thames and impassable roads everywhere.

On Christmas Day, the official thermometer at Greenwich fell to eleven degrees Fahrenheit[62] and this famously cold and snowy Christmas seems to have set the tone for depictions of the festive season down to the present day. We still send Christmas cards showing stage coaches dashing through snow-bound villages and well-wrapped waits with lanterns who could have stepped straight out of what must have been Favell's most interesting Christmas. For whichever member of the Bevan family it was who dealt with the visit of the Swing rioters, Favell was not present. She had already gone to Norfolk for a Christmas holiday with her uncle who was rector of Carlton Rode.

At Fosbury, Favell had found poor, prayerful people with whom she could be one at heart and they were as different from the associates of her ballroom days as can be imagined. In Norfolk, she made another set of new friends and once again they were nothing like her old worldly companions. At Carlton Rode, she found her uncle's visitors and neighbours were as cultured and well-educated as her Fosbury friends were unsophisticated and simple. However, they were also completely devoid of worldly ambitions and indifferent to worldly success. The Fosbury peasants were a contrast to the polite and materialistic society into which Favell's mother had once thrust her. Before she was converted her Uncle's friends and associates would have formed a contrast every bit as painful and even embarrassing – although for different reasons. But Favell was a believer now and she welcomed eagerly the opportunity for true fellowship with these Christians of very wide experience. She embraced all they had to tell her and wrote her impressions of them in her journals. The stories they told and the insights they were able to give were carefully stored away and later formed a part of her life's great work.[63]

First was her Uncle's neighbour, the fascinating John Venning (1776-1858), a Christian merchant from Devonshire who had lived for many years in St Petersburg. He had just arrived in Norfolk where he was to spend the rest of his life. In Russia, he had worked at prison reform and also on behalf of the inmates of lunatic asylums, submitting his reports and suggestions to Tsar Alexander I (The Christian Tsar) and Tsar Nicholas I (his unconverted successor).[64] He had also travelled extensively in Europe in the same cause. Venning recounted to Favell how he had been called in by a prison officer who was trying to deal with a riot. Bravely, Mr Venning walked into the prison to confront the ringleader, a ruffian who was proclaiming that he was not afraid of death – after all, he could only die once.

"But after death?" asked Mr Venning.

"The judgment," came the almost automatic answer.

"And have you ever considered that?" asked Mr Venning.

Quickly he turned to John's Gospel chapter three and read out the story of Nicodemus with its telling lines:

"Except a man be born again, He cannot see the kingdom of God... For God so loved the world, that He gave His only begotten Son, that whosoever believeth in Him should not perish, but have everlasting life.... For every one that doeth evil hateth the light, neither cometh to the light, lest his deeds should be reproved. But he that doeth truth cometh to the light, that his deeds may be made manifest, that they are wrought in God..."

The hardened criminal broke down in tears – the riot was over.

Then, despite the weather, there was a visit to the vicar of Old Newton, Suffolk, Charles Bridges, (1794-1869)[65] whose heart-searching commentaries on Psalm 119 and on the Book of Proverbs were later highly recommended by Spurgeon. Favell was also introduced to the MP for Cockermouth, William Carus (1764-1851). Carus had been an associate of Charles Simeon's at Cambridge and later he wrote the biography of this influential Church of England evangelical. Favell took careful note that, although obviously a brilliant thinker, Carus could explain almost any subject in very simple terms so that the lowliest intellect could grasp what he was saying. Here was a skill of inestimable value to any Christian worker which she could observe closely and learn to imitate.

It was not until 1832 that Favell returned to Fosbury to establish a school funded, at least initially, by her father.[66] What had happened to the school Sylvanus had established is not clear; it evidently had ceased to operate although the building remained. Favell had been teaching in schools for poor children since she was a child herself; now she was being given a school to manage which would be solely her personal responsibility. Was she anxious to succeed? "Few things succeed in the *first* attempt," she wrote to her mother from Fosbury, "The work is the Lord's – He will provide."

Favell set to work on her task with a will. The village mothers

were asked to bring their children to the schoolroom at three o' clock one afternoon. Sarah Farr encouraged them to come and Favell was able to take down the names of sixty-eight children who were to be sent to the school. She explained the object of the school to the assembled mothers and concluded the little meeting with prayer.

And what was the object of the school? It was that the children should hear the gospel and that they should learn to read in order to read God's Word for themselves. The surviving accessible sources do not indicate whether or not writing was also taught at the school; perhaps, as in other voluntary village schools of this period, only reading was on the timetable.

A teacher was engaged but Favell gave the Scripture lessons herself. We can eavesdrop on one of her lessons in a passage from her first book:[67]

Who is it that dresses you and feeds you? – Your dear mother. But how does your mother get money to buy the clothes and the food? – Father brings it home. How does your father get money? – He works in the fields. Your father works all day long, and he gets money and brings it home to mother. He says to your mother, 'Buy some bread with this money, and give some of it to the children.' Will your father give his money to buy bread for you? That is very kind of him. Do you love your father? How hard your poor father works in the fields! What is your father, little Ann? – 'He is a thresher.' Your father, then, works hard in the farm. In the spring he takes his scythe to mow the grass, and as he mows he bends his back till it aches. In harvest-time he takes his sickle and reaps, while the hot sun beats upon his poor head. Afterwards he threshes the corn with all his strength. In the cold weather he follows the plough, while the cold rain and sleet beat upon his face. Why does he bear all this? That you may have plenty of food, and be fat and rosy. While he is ploughing, he often thinks of you, and hopes that he shall find you a good child when he comes home. You are glad to see him, I know. Sometimes

you run to meet him, you set a chair by the fire, and then you climb upon his knee. Sometimes he is too much tired to speak to you. Then you wait till he has had his supper. What is your father, Mary? – 'A shepherd.' Your father watches the sheep all day long. Sometimes he gets up in the night to look after the young lambs and the sick sheep. What kind fathers God has given you! Who made your father love you at first? – It was God. Your father loves you so much that he gives you all you want. He has a little cottage, and he pays some of his money for it, but he allows you to live in it with him. He lets you sit upon one of his chairs, or upon a little stool by his nice warm fire; and he gives you some of his breakfast, dinner, and supper... But if God were to let your father die, you would still have one father left. Whom do I mean? What do you say in your prayer? – 'Our Father who art in heaven.' Yes, you have a Father in heaven, besides the father you have at home, for God is your Father.

Can your heavenly Father die? – No, never. Does He love you? –Yes. He loves you even more than your other father does. He is always thinking of you. He is always looking at you. He gives you part of His things. He would like you to come and live with Him in heaven some day. He loves your father too. He is the Father of your father.[68]

In this tender and familiar way Favell introduced the little ones of a country school to the idea of God's fatherly care.

Discipline in the Fosbury school was maintained by a method familiar in Sunday schools down to the present day: the distribution of little tickets as rewards which could be cashed in for prizes. There is a detailed description of how this system may have worked from Favell's younger brother, Barclay. Some fifteen years later he was operating something similar in his Sunday school at Burton Latimer, Northamptonshire. He explained:

From January, 1845, tickets may be given in our Sunday-school as follows:

<u>Morning Tickets.</u>

For attendance before prayers commence	...1
For perfect lessons	...1
For good conduct	...1
For good behaviour in Church	...1

<u>Afternoon Tickets.</u>

For punctuality at School	...1
For good conduct	...1
For good behaviour in Church	...1

Each child has the opportunity of getting seven tickets on a Sunday; and if the child is short of any, the parents must find out the reason.

28 Little tickets merit one large ticket.

6 Large tickets obtain a first prize and a medal.

5 Large tickets obtain a second prize.

4 Large tickets obtain a third prize.

3 Large tickets obtain a fourth prize.

Twenty-eight tickets may be exchanged for one large one, at the Rectory, on the first Saturday morning of every month, at half-past nine o'clock. Factory and working children may come up the same evening at seven. By this plan every child will be rewarded according to merit. May God prosper the endeavours of both parents and teachers.[69]

The other method used to maintain order is certainly no longer in favour. The little boys (always a potential source of bad behaviour!) in Favell's school at Fosbury were taught to plait. This sounds strange until it is realised that the plaiting of wheat straw to be used in hat and bonnet making was a vital home industry. The boys, their hands occupied with the straw, could still engage their

minds on the teacher's instruction – and have something valuable to take home to their mothers. No wonder they continued to be sent regularly!

The cottagers Lizzie and Betty who lived by the schoolhouse were deeply fond of the children, "[t]hese two dames watched over the children as they played in their playground. Dear Lizzie took the trouble of begging cabbage leaves from the bailiff next door and making warm green soup for the little ones from a distance."[70]

Eventually Favell found that the teacher she employed was not as good as she had hoped, but nevertheless a promising start was made. The teacher's recommendation was that she had previously been employed in a similar school run by Rev William Lisle Bowles (1762-1850) at Bremhill some thirty miles from Fosbury. Bowles was a poet – of sorts – and his "Children's Hymn For Their Patroness" perhaps gives a flavour of the kind of schooling the new Fosbury teacher had had to deliver under her previous employer. An introductory verse acknowledges God's goodness but after that four verses are devoted to thanking not the children's God but their Patroness!

Oh God, whose eyes are over all,
Who shows to all a father's care,
First, with each voice, we children call,
And humbly raise our daily prayer.

And next, to her, who placed us here,
The path of knowledge to pursue,
(Oh! witness all we have – a tear!)
Our heartfelt gratitude is due.

Our parents, when they draw their breath,
In pain, and to the grave descend,
Shall smile upon the bed of death,
To think their children have a friend.

As slow our infant thoughts expand,
And life unfolds its opening road,
We still shall bless the bounteous hand
That kind protection first bestowed.

And still, with fervour we shall pray,
When she to distant scenes shall go;
That God, in blessing, might repay
The blessings which to her we owe!

One can imagine that Favell, so modest that at the height of her popularity almost no one knew her name, would find it very distasteful to be greeted with this sort of thing!

Favell could not stay in Fosbury for ever in order to teach the Scripture classes in the school. Accordingly she began to write down the lessons she gave in order that the teacher might carry on with them in exactly the same way. For years she had been honing her skill. She had become an expert at simple gospel presentation to very young children: now she committed the lessons to writing. Miss Clare, Dr Collison, Mr Carus, they probably never dreamed their influence would bear such fruit. The sun was beginning to rise on *The Peep of Day.*

Endnotes

[57]Meyer p.49

[58]Meyer p.58. It is probable that Meyer met Lizzie and Betty herself when she was a child.

[59]Meyer p.63

[60]Request of the labourers of Steep near Petersfield, Sussex quoted in Hobsbawm, E.J. and Rudé, George, *Captain Swing*, (London,1969) p119.

[61]See Chapter 8.

[62]Minus twelve degrees centigrade.

[63]See Chapter 9.

[64]See Masters, Peter, *Men of Destiny*, (London 1989).

[65]See Chapter 9.

[66]Later Favell funded the running costs herself.

[67]Omitted from later editions.

[68]*Peep of Day*, (London, 1833) p.24.

[69]*The Teacher's Visitor July—December, 1845*, edited by William Carus Wilson.

[70]Meyer p.58.

Chapter Four (1830-1833)
Henry Edward Manning

During the time that she was soaking up the godly influences at her Uncle's home and establishing the school at Fosbury another pupil was given to Favell. He was of a very different stamp to the humble little boys and girls of Fosbury or Belmont and her utter failure to reach him with the gospel resonated for the rest of her life.

Henry Edward Manning (1808-1892) was born at Copped Hall, Totteridge (later the home of the Hall family)[71] near the Bevan family home at Belmont. His father, William Manning, had been one of Wilberforce's supporters and the young Manning was a close friend of Robert Bevan, his contemporary at Harrow and later at university. His seriousness seems to have impressed Favell. When she was concerned about Robert's spiritual state, it was his friendship with the young Manning that gave her some crumbs of comfort. Manning spent the vacations from Oxford at Belmont and was there in 1830 not long after his father's financial ruin plunged him into difficult circumstances. He was now no longer able to pursue the parliamentary career which had been his aim.

"The total ruin of his fortune does not lessen him [Manning] in his [Robert's] esteem," wrote Favell at the time, "I greatly admire the candour of Manning. It affords a good foundation on which to raise the superstructure of truth."[72] Alas, the superstructure that Manning was to erect on this foundation was to be totally different to anything that Favell would have wished or imagined.

Favell empathised with Manning's disappointment at having to give up his cherished hopes of entering parliament, and tried to raise his spirits as they strolled through the Belmont grounds.

"There are higher aims still that you have not thought of," she told him.

"What are they?" he asked.

"The Kingdom of Heaven; heavenly ambitions are not closed against you,"[73] she replied, evidently trying to turn his mind from an earthly parliament to something infinitely more serious and solemn.

He seemed to be listening and replied that he did not know but that she was right. Favell followed this up with the suggestion that they should read the Bible together and that she was sure that Robert would join with them in doing so.

The three of them read the Bible together every morning during the vacation and when Manning had to go back to Oxford, Favell suggested that they continue their reading scheme and carry on reading the same passages; she at Belmont and Manning at Oxford. They would continue their discussions on the topics raised by means of letters. A voluminous correspondence ensued between them.

On another visit to Belmont, Manning joined in a scheme of learning selected verses from the book of *Proverbs*, repeating the verses at tea every day. Manning studied his verses with zest and accompanied his recitations with his own observations on the proverbs in question.

"His remarks are always acute and refined," noted Favell, "He seemed to like those proverbs which praised diligence and knowledge."[74]

They began lending one another books. At this time Favell was enjoying reading the works of the leading Baptist, Robert Hall

(1764-1831)[75] and also the sermons of John Cennick (1718-1755), the great Calvinistic Methodist evangelist. Manning lent her *On the Origin of Romanism* by Richard Whately (1787-1863), the newly appointed Archbishop of Dublin. This interested her but brought "no conviction to the mind of its author's vital piety,"[76] something which must have struck her forcibly when reading this dry and academic Church of England archbishop alongside the practical Hall and earnest Cennick. On the other hand, the theology of Thomas Scott's *Commentaries* which had been so helpful to Favell sometimes made Manning angry.

"I have had several serious conversations with him," she wrote, "I think his talents very great, his candour and independence of mind singular, but pride, I fear, predominates, the pride of virtue."[77]

When Manning confessed himself puzzled on the subject of election, Favell got him to read Dean Hugh M'Neile's *Sermons on God's Sovereignty and Fatherly Affection.* M'Neile deals with the issue in a very thoughtful way, "What would Adam have said," he asks in effect, "if before the fall he had been informed that the councils of eternity had decreed that Christ should come and save His people from their sin? 'Must I sin then?' he would have asked. But he was kept in ignorance in order that his freedom of action would not be circumscribed." Manning told her he appreciated the honest discussion of the difficulties in M'Neile but was silent on whether he agreed with the Dean's conclusions.

"I enjoy rational conversation so much," wrote Favell, "that I regret the little time that pleasure can last. All human pleasures are trifles, and their pursuit is the Christian's bane; his calling is to show forth God's praises in every situation. I agree with Manning in liking the philosophy of history and the biography of life. I like to stop and moralise at every step, to review, compare, conclude, and establish principles as I go."[78]

There is no doubt that Favell fell in love with Manning, her junior by six years, bowled over by his powerful intellect and by his recognition of her own. Her conscience smote her for becoming

involved with a young man who, although newly awakened to the importance of religion and eager to discuss the topic, was not converted. She quieted it by citing what she hoped was a "work of grace going on in his heart."[79] Their conversations she admitted were, "exceedingly pleasant," but added, "how far they are profitable is doubtful."[80] She found him, "uncommonly well-informed," and with a "much greater capacity of judgment than myself," adding a warning to herself at once, "when the heart is not under captivity to the Gospel, every sentence must be received with caution."[81] But no matter how much enjoyable conversation they had, Manning never seemed to move forward – at least not in a direction that Favell would have considered beneficial – but "remained at the gate knocking."[82]

"H. Manning's candour and calmness make him a very inoffensive opponent in argument, and his logical powers make him a very formidable one," she wrote, "I feel the overwhelming superiority of the importance of his conversion to vital religion so deeply, that I am resigned to merge minor differences in one great common bond. Our last conversation was very serious... Reflecting on his conversation I perceive he is in bondage to the law. I feel my insufficiency as a guide."[83]

They continued to meet and Manning was often at Belmont. When Favell was away at Fosbury setting up the school, they corresponded. She attended a meeting while at Fosbury (presumably held in the Schoolroom) conducted by a Primitive Methodist itinerant preacher (almost certainly the Primitive Methodist pioneer, Thomas Russell [1806-1889]) and she wrote all about it to Manning. She described the speaker's "earnest pleading" and no doubt hoped Manning too would be moved. He was merely "interested" and moved on from pondering election to prophecy. He wished to be "furnished with texts on the Personal Coming," by her and continued to find obstacles in his way until Favell almost despaired. "[H]ow often do fair appearances perish in the bud!" she wrote, "[h]ow difficult it is to reconcile the mind to such a prospect in any particular case! Perhaps it is well not to be reconciled to it. Samuel mourned for Saul till the day of his death."

Her mother, Mrs Bevan, sounded a note of caution. "Do not be too anxious nor elated at his praise of your reasoning, nor allude to *his* talents," she wrote to her daughter, "[t]he change would, indeed, be sudden from inflamed ambition to deadness to the world," adding that Manning was in God's hands. He alone could change him, "[a]nd if He does not, there is a cause, with which no anxiety on our part for His glory, or for the best being of the individual we hope will promote it, can interfere."

Manning went with Favell (presumably along with the rest of the family) to hear William Howels preach at the Episcopal Chapel in Longacre. How she must have hoped that Howels' quaint but popular preaching would have the same effect on Manning as it had had on her brother-in-law Bosanquet! Alas, the "cracked-voiced Welshman in Longacre" may have been "a wonderful and original thinker," who "greatly arrested" Manning at the time but later he was to describe him as "unintelligible."[84]

Amidst all the soul-searching Henry Manning had still to decide on a new career. To take orders and become a Church of England minister would be easy but amid all these doubts and mental conflicts an honest mind would not take such a course. On the other hand, if he were to work at the law for a few years he might collect together enough money to enable him to set out on his cherished ambition of a political career. In the end, he took a lowly post at the Colonial Office. He stuck at this for only a short time and then left to take orders. Favell must have been in a very anxious state. He had "great mental endowments," was "much interested in the Scriptures," could "debate with unparalleled candour," and was "sensitive and impressionable", but she knew in her heart that he was utterly unsuited to be a minister of the gospel because he had no heart experience of true religion.

By this time, Mrs Bevan was beyond merely urging caution. Favell was plunging down a slope that alarmed her. And well it might. "Merging minor differences in one great common bond" seemed to be less likely to lead to his conversion to "vital religion" than hers from it. In the past, Mrs Bevan had shown a lack of judgment when she immersed her girls in the Jane Austen world

of the ballroom marriage market. Now, in contrast, she exhibited great foresight. Due to her, Favell was saved from a marriage which would have been a disaster. Mrs Bevan knew Manning was not converted. In May 1832 she advised her daughter to close her correspondence with him. Favell obeyed.

Manning went to Lavington in Sussex where he became curate to John Sargent (1780-1833). A friend and supporter of Charles Simeon, Sargent was a godly man, with whom William Wilberforce had trusted his son Henry for his early education. The following year Favell noted in her journal without comment: "November 7th. H. Manning was married to C. Sargent."[85]

Mrs Bevan had spotted the one vital thing which the Sargents had overlooked. One cannot help conjecturing that if John and Mary Sargent had had any inkling of Manning's true spiritual state, they would have been as reluctant as Mrs Bevan to allow their daughter, Caroline, to become involved with him. Two of Caroline's sisters married sons of William Wilberforce and a third married a son of Henry Ryder (1777-1836), the first of the evangelicals in the Church of England to be made a bishop. All these sons-in-law of John Sargent eventually moved away from their parents' evangelicalism, although – if it is possible to measure distances in such a matter – some moved further than others. But in 1832 all this was in the future. It would be many years before Favell would know for certain how wise her mother's painful judgment had been.

Endnotes

[71]This was where Mary Hall, Favell's friend, lived. See Chapter 2.

[72]Meyer p.34-5

[73]Purcell, Edmund Sheridan, *Life of Cardinal Manning, Archbishop of Westminster,* (London,1896) Vol. 1. p.63

[74]Meyer p.35

[75]Robert Hall wrote about the importance of education for the poor. See Chapter 11. Though interesting to read, his theology was tainted with the same problems over the Trinity that had affected Harrington Evans and Favell's Uncle George.

[76]Meyer p.35

[77]Meyer p.35-36

[78]Meyer p.36

[79]Meyer p.38

[80]Meyer p.37

[81]Meyer p.37

[82]Meyer p.42

[83]Meyer p.43

[84]Purcell, Edmund Sheridan, *Life of Cardinal Manning, Archbishop of Westminster,* (London, 1896) Vol. 1. p.64.

[85]Bevan, Edwyn, "The Peep of Day A Lawgiver in the Nursery, The Long Reign of Miss Bevan" *The Times,* (London, 27th June 1933). Caroline Sargent (d.1837) was the daughter of John and Mary Sargent.

Chapter Five (1833-1838)
The Baby Book

When the Bevans moved from Hale End, they seem to have completely lost touch with Dr Collison, their minister from Marsh Street Chapel days. All through the difficulties of David Bevan's illness, Favell's relationship with Manning, Robert's conversion, and Louisa's troubles and return to faith, he is out of the picture. Then suddenly in 1834 after Louisa and her family were settled at Osidge, Favell's niece tells us, "One Sunday they went with their brother Barclay to hear Dr Collison once more, and very much enjoyed worshipping again with him, and listening to his well-known voice which they had not heard for ten years."[86] The phrase "with their brother Barclay" sounds almost as if Barclay was in the habit of attending Dr Collison's church already or was at least in touch with him in a way that the rest of the family was not. Barclay had been a child of about eleven when they moved from Hale End to Belmont whereas the girls were grown up. Did he have a special attachment to Dr Collison? Certainly this visit to Marsh Street cannot have been a sudden, unpremeditated whim with no cause behind it.

The description of the meeting with the venerable minister sounds exactly like a reconciliation. Their old friend preached on the carnal and spiritual mind (probably from Romans 8 v. 6) and "what the Favour and Friendship of God are to His people."[87] After the service Dr Collison welcomed the Bevans into the vestry, receiving them "with the warmth and benignity of a father."[88] Soon afterwards he visited them at Belmont; clearly he had never been invited there before. It seems to have been an emotional occasion. "As he spoke and prayed, it seemed as if St Paul or St John were

again blessing 'the elect lady and her children.'"[89] Whatever had caused the rift, it was now healed.

Meanwhile, in 1833 Favell had made her first foray into print. It is not often that an author has such an enormous, unexpected success with a first book. "I took *Peep of Day* to Hatchard, who undertook to publish it,"[90] she noted briefly in her journal. On the day when she walked into the bookshop with her manuscript neither she nor Hatchard could have had any idea of the immense popular success the book would have.

The popularity of what Favell described as her "Baby Book" was truly awe-inspiring and it out-lived her by many years. Despite changes in taste, fashion, and even religious outlook, it continued to provide staple first religious instruction to perhaps millions of children. In Favell's own lifetime it was to be found in almost every nursery in the land. Much used by missionaries it was to be translated into at least thirty-seven languages and dialects including Urdu, Yoruba, Cree, Matabele, Gujerati and Rarotongan through the agency of the Religious Tract Society. Edition after edition came out in English, some with better illustrations, some, in the course of time, with her matter of fact references to Hell toned down, some just as she had originally written it. Still in print today, it is impossible to compute, for purposes of comparison, how many copies have been sold in total. It is quite possible that it surpasses even those later children's books that were best sellers such as *Alice in Wonderland*.

What made this little book so popular? There is no doubt that it reached the market just at the point when something of this character was most in demand. In 1833 the evangelical revival of the early nineteenth century was at its height and almost all respectable people whether evangelical or not now wished to give their children some religious instruction. There is no doubt that the title was an inspiration. Favell had a genius for titles as her later output showed.[91] Its small size too, on which she insisted, was influential in an age when the idea of small things for small people trumped any consideration of type-size for junior readers. Then there was the striking and most memorable pair of questions with which the book opens:

Who put the sun in the sky? – God.

Can you reach up so high? – No.

It cannot be an accident that these first two questions rhyme although the rest of the book has no rhyming element. They lodge as firmly in the mind of a toddler as "What is the chief end of man?"[92] or "What is your only comfort in life and in death?"[93] lodge in the minds of older people. These questions open the great matters of life to the very young through something concrete that they can apprehend.

Favell's long experience of teaching in voluntary schools, where children's attendance could not be enforced, made her a master of the "bite-sized" lesson. She learned to deliver sound Bible teaching by delicious teaspoonfuls. The book is as ideal for a child on a mother's lap as for a lively class. Favell learned from her own childhood governess, Miss Clare, the value of short memorable lessons often in the form of questions. These allow a child to respond or even give an opinion or experience that a skilful teacher can use to make her own point. The book appealed also to Christian parents of all denominations. Favell, although by now a member of the evangelical wing of the Church of England, had been raised under Dr Collison, an Independent. She read with equal pleasure and profit the works of Baptists such as Robert Hall or churchmen like Scott and Cecil. There was nothing in the *Peep of Day* that tied it to either church or to dissent, to baptist or to paedobaptist.

How was all this achieved? Favell did not just sit down and write the book. It was a product of continuous research and refinement that she tested out, over and over again, before it went into print. The process was at first an oral one. Each lesson she gave was honed and adapted in response to the reception it received from the children themselves. There is a description from much later in her life of how she tested her work on the obnoxious little Cecil Forester – "so disobedient and void of feeling so utterly intractable that I earnestly long to have done with him," wrote his poor tutor.[94] For a short time each afternoon, Lord and Lady

Forester lent Cecil to Favell as her "censor."[95] At the time she was working on her geography books *Far Off* and *Nearer Home.* Her method was simple: she read what she had written to Cecil. When she saw that his attention wandered or he was not interested in something, it was ruthlessly cut out of the manuscript.

Hatchard was the ideal publisher for such an enterprise as Favell's. John Hatchard (1769-1849) was one of the circle that had surrounded Wilberforce, and his premises were used for meetings of the anti-slavery society in its early days. By the time Favell arrived at the shop and sent up her visiting card in 1833, venerable old John Hatchard, who dressed in a black frock coat and knee breeches like a bishop, had handed the day to day running of the business to his son, Thomas. Thomas, in complete contrast to his father, affected a blue dress coat with a velvet collar and gilt buttons, a white cravat, a yellow waistcoat and brown nankeen[96] trousers but he was just as kind and just as good a judge of a book. It was probably Thomas who gave the go-ahead to the publication of what must have been Hatchard's greatest single money spinner. The firm specialised in religious titles and besides being Wilberforce's own publisher they also made a point of including books by dissenters in their catalogue. Hatchards already had a number of children's titles in their list including Mrs Sherwood's very popular *History of the Fairchild Family or the Child's Manual.* Favell's book was very different.

In *Peep of Day* it is possible almost to see Favell herself surrounded by the village children of her school at Fosbury or with her nieces and nephews on her lap:

> Are you not very sorry to hear that Adam and Eve were turned out of the garden? It was not so pleasant outside of the garden. A great many weeds and thistles grew outside; but in the garden there were only pretty flowers and sweet fruits.
>
> Adam was forced to dig the ground till he was hot and tired, for he could not always find fruit upon the trees.
>
> Now Adam felt pain in his body sometimes; and his hair became grey, and at last he was quite old.

Eve was very often sick and weak, and tears ran down her cheeks.

Poor Adam and Eve! if you had obeyed God you would have been happy for ever.

Adam and Eve knew that they must die at last. God gave them some little children; and Adam and Eve knew that their children must die too. God had told them that their bodies were made of dust, and that they must turn to dust again.

But there was something more sad still. They were grown wicked. They did not love praising God, as they once had done, but they liked doing many naughty things. Satan hoped they would be punished with him, for he knew that wicked people cannot live with God in heaven.

How very sad this was for Adam and Eve and for all their children too! But God took pity on them. God is so very kind that He had found out a way to save them. God had said to His Son a long, long while before, 'Adam and Eve and all their children must be punished for their wickedness unless you die instead of them. My beloved Son, I will send you; you shall have a body; you shall go and live in the world, and you shall obey me, and you shall die for Adam and his children.'

Here was basic Bible teaching – theology even – reduced to the very simplest terms. The book was a sell out. There was nothing else quite like it. This may seem surprising now. We are used to a wide variety of colourful books aimed at explaining Bible truths to children, but in 1833 things were different. The Victorian era which, if it did not actually invent childhood certainly fostered its development, had not even begun. Favell was firmly of the opinion that "Scripture doctrines can be gathered [by children] from the Sacred Narrative with more truth and vividness, though with less regularity of system, than from creeds and catechisms,"[97] and this was what drove her to try to help children to understand the Bible itself from a very young age.

Hatchard must naturally have been keen to publish further books "by the author of *The Peep of Day*" as their covers always modestly proclaimed and certainly that designation quickly became famous enough to sell any new title. *Line Upon Line* followed, telling the Old Testament histories in order and then *Lines Left Out* for slightly older children which narrated incidents and events omitted from the previous book as being too difficult to understand at an early age.

We know that later in life Favell was earning a very substantial sum from her books each year[98] but it is not clear from the available sources whether *Peep of Day* itself and its immediate successors were simply sold outright to the publisher as was common practice at the time. Her use of her own money for the Fosbury school is documented by her niece who saw the accounts in her journal of her expenditure. These showed that of the allowance she received from her father of £200 a year, £60 was spent on her personal needs and the rest went to the maintenance of the Fosbury school.[99] No doubt any profits from *Peep* and *Line* were dedicated to similar good causes.

Favell's approach to her task was plain and direct. There were other possibilities. Mrs Sherwood, in her *History of the Fairchild Family*, created an imaginary family to engage the interest of the young reader in the moral and religious instruction she had to give. The children in the story demonstrated the various behaviours and ideas she wished to teach or to warn against. Her fictional writing has definitely stood up to the passing of time less well than Favell's factual material. The following extract taken almost at random gives an idea of the Fairchild family's rather smug character:

"I cannot think where John [the serving man] can be," said [little] Henry: "I thought he would be here long before this time."

"Do not be impatient, my dear," said Mr. Fairchild: "impatience is not pleasing in the eye of your Heavenly Father."

By this time they were come to the brow of a rising ground;

and, looking before them, behold, there was John at a distance! The children all ran forward to meet him:

"Where are the books, John? Oh, where are the books?" they all said with one voice.

John, who was a very good-natured man, as I have before said, smiled, and, stopping his horse, began to feel into his pockets; and soon brought out, from among many other things, three little gilt books; the largest of which he gave to Lucy, the least to Henry, and the third to Emily; saying, "Here is one pennyworth — and here is two pennyworth — and there is three pennyworth."

"Indeed, John, you are very good," said the children: "what beautiful books!"

"Here are many beautiful pictures in mine," said Henry: "it is about a covetous woman— 'The History of the Covetous Woman': I never read that story before."

"My book," said Emily, "is 'The History of the Orphan Boy': and there are a great many pictures in it: the first is the picture of a funeral — that must be the funeral of the poor little boy's papa or mamma, I suppose."

"Let me see, let me see," said Henry: "O how pretty! And what's your book, Lucy?"

Favell always regarded this fictional device as of doubtful value. Her task was instead to take the narrative of Scripture itself and by well crafted explanation, omission and substitution of words to enable a child to understand it. She likened this task to that of a commentator such as Thomas Scott. A commentator takes the difficulties met with by the adult Bible reader and tries to provide an explanation. *The Peep of Day* and its successors were a highly successful attempt to explain the difficulties a *child* would meet with in language *he* could grasp. Favell had found that children "always asked, 'but is it true, Miss?'" when told a story and she discovered that if the answer was negative the example lost its power. True stories made more of an impression. She, therefore, avoided Mrs Sherwood's method and concentrated instead on relating the Scripture narrative in a child's language.

In her books the lessons point out to the child the necessity of repentance and salvation, drawing the point directly from the topic or history narrated. This is never forced and always flows naturally from the text under discussion:

> Why was it so wicked of Saul not to kill the king of the Amalekites and the fat cattle? Because God had told him to kill them. We ought to do what God tells us to do. Has He told you to kill wicked people? No; but He has told you to pray to Him, and to be kind, and to speak truth, and, first of all, to believe on the Lord Jesus Christ.[100]

But if grateful parents and teachers seized on the books sending them to the top of what would now be the best-sellers lists, they were not without their critics. Some people disliked them intensely and for the very reasons that made them successful.

"The reviewer has heard with great pain," wrote the *British Magazine and Monthly Register of Religious and Ecclesiastical Information* when reviewing (quite unasked and uninvited) *Peep of Day* and *Line Upon Line* in 1838, "that... [these books have] gained *very wide* circulation." He goes on:

> It is the work of a lady and evidently written with the best of intentions. It is the more painful to be obliged to say of it, as he must in conscience, that he has seldom seen a book so likely to be mischievous to children, or one which all parents who wish to preserve in their children's minds the proper tone of reverence for sacred things, should more studiously keep out of their way. Inconsiderate people are perpetually complaining of the difficulty of getting children to realize, as they call it, what they read. And no doubt it is a difficulty for children of either a smaller or larger growth to "realize" any other scenes which may be described to them than those which consist principally of elements with which they are quite familiar. This difficulty does not belong to children only, but to all minds of confined views, and therefore to children only as long as their views are confined. As they grow older, and conversant, from month to month, with

more and higher things, they can "realize" more and more of what they read.

Incensed that Favell had (in his opinion) stripped the sacred narrative of reverence, the reviewer sneered at her for bringing it, "down to the level of common, mean, every-day life," and talking about jugs instead of pitchers and supper instead of the Passover, insisting instead that children should be left until they are old enough to understand what the Bible says for themselves:

> In one word, strip scripture characters of everything which a young child cannot understand, (that is to say, of everything which makes scripture precious,) and then the young child will understand it. Yes! he will, and so long as he lives, will read, and understand it in the same way; that is to say, as a common-place history of every-day life, not calculated to excite any higher emotions than a novel or a newspaper.

If Favell was hurt by this tirade she could comfort herself with the reflection that in her own personal experience her reverence for the Scripture as an adult had certainly not been harmed by the easy and gentle introduction provided by Miss Clare. It was also valid to ask what was to become of the numbers of little ones who died in early childhood? Were they to go to the grave untaught and unsaved because they were too young to understand the Scriptures without help? Many years later when her brother Robert's little three year old Ada died of scarlet fever, Favell was able to witness the last weeks of a tiny child who died having made a clear profession of faith, who had asked to hear Favell's book *Streaks of Light* over and over again in her last illness and whose final whispered words of joyful recognition as she passed into glory were "pretty Lord!"

"Upon trial," wrote Favell,

> it will be found that children can understand religious truths at a very early age; although the exact period is of course very different in different individuals. The sophistries which sinful inclinations suggest to the mind as life advances do

not obscure the infant intellect. The child easily perceives that there must be a God, and acknowledges His power to be great, the only objections it raises to any doctrine are such, in general, as have never been solved by man, while the child finds no difficulty in believing that God's understanding is infinitely greater than its own. And will it be deemed undesirable to instruct the infant in religion, when it is remembered that impressions made early on the mind are the most vivid and the most durable;– that the readiest access is obtained to the young and tender heart; that wrong notions will be conceived by the ever busy intellect, if left uninstructed; and that life being uncertain, the eternal happiness of a child, already knowing good from evil, may be endangered by delay?[101]

To her mother she explained:

The ideas of a child and of an adult as to the dignity of sacred subjects are totally distinct. I write for *children*. Were many things which are alluded to in Scripture as familiar to us as they were to those for whom the Scriptures were first written, they would lose their fictitious dignity. "Two women at the mill" – What should we say to two women at the mangle? It is very important with children to be familiar. If an allusion requires explanation, the effect of the sentiment is lost to them.[102]

Ada's favourite book, *Streaks of Light*, was originally a collection of little tracts called *Tracts for Children in Streets and Lanes, Highways and Hedges*, which Favell wrote and which were later bound together to form a book. Tracts containing religious or moral teaching were immensely popular at the time and the most famous tract writer was Miss Hannah More (1745-1833). Miss More was an associate of Wilberforce's who had made it her life's work to help and educate the poor especially through the founding of schools. Her idea was to replace the vast volume of rubbishy chapbooks, sold for very small sums to the poor, with some more wholesome reading in the form of tracts. Her first tract, *The Shepherd of Salisbury Plain*, was an outstanding hit. Bought

by the thousand for free distribution as Sunday School and Day School prizes or for sale at a very low price to the poor directly, it set the tone for a vast *oeuvre*. The simple story of patient goodness rewarded and poverty borne with humble perseverance has a too-good-to-be-true feel to the modern reader although More claimed it was based on a factual story. Like the host of fictional tracts by More that followed it, the ideas it aimed to teach were no doubt worthy and even Christian in principle but *Streaks of Light*, though aimed at almost the same market, was a very different collection. Favell's idea was not so much to amuse, and slip in an important message along the way, but to awaken. The set contained fifty-two tracts so that they could be collected by a child or awarded by a teacher at a rate of one per week over a year. One can imagine children trying to get a full set or even swapping them with each other rather in the way that various sets of cards have been popular with children of later generations. In these fifty-two tiny lessons Favell managed to cover the whole gist of the Bible beginning at Genesis Chapter One in the first tract and ending with Revelation in the last. It is a remarkable achievement and Dr Collison must have be more than satisfied when he saw the ultimate end of all the "theme" writing he had prompted in Favell's childhood.

To read the Bible for yourself, of course, you must learn to read. This is best achieved during childhood and Favell was concerned that learning to read was more difficult and painful than was truly necessary.

"You think me foolish to call instruction a torment; but if you had been as much used as myself to hear poor little children first learning their letters, and then learning to spell, if you had seen how stupid they can be for a whole morning together, and how tired my poor mother is at the end of it, as I am in the habit of seeing almost every day of my life at home, you would allow, that to *torment* and to *instruct* might sometimes be used as synonymous words," says Catherine in Jane Austen's *Northanger Abbey*. Favell was only too aware of this aspect of teaching. By the time *Peep of Day* was published she had honed her method of teaching reading into something far less formidable for both child and teacher by means of a simple invention of her own: flash cards.

In 1834, Favell embarked on the publication of her own method of teaching reading. There had already been attempts to get the teaching of reading onto a more systematic footing than that of the old horn books.[103] Favell used the phonetic and syllabic approach popularised by Mrs Honoria Williams[104] but what made Favell's *Reading Disentangled* unique was the set of illustrated flash cards, included with the book. Each of these contained a letter or combination of letters forming a specific sound, together with an example word and appropriate picture. That the letters printed on the cards were very large was no doubt also a contribution to success. The result of years of practice, this sensible and well thought out technique quickly replaced the earlier more *ad hoc* methods and that of Mrs Williams herself. Favell had invented a very useful teaching aid that is still in use in various forms today. When, as a middle-aged lady, she re-vamped the book completely she gave it a new and brilliant title: *Reading Without Tears*, which still resonates today. A quick internet search reveals "Handwriting Without Tears," "Knitting Without Tears," Travel, Statistics, Topology... even without the most famous reference of all, Terence Rattigan's 1936 play *French Without Tears*.

Endnotes

[86]Meyer p.62.

[87]Meyer p.62

[88]Meyer pp.62-3.

[89]A reference to 2 John 1:1. Meyer p.63.

[90]Meyer p.52.

[91]See *Reading Without Tears* below.

[92]Opening question of the *Westminster Shorter Catechism*.

[93]Opening question of the *Heidelberg Catechism*.

[94]Young, Mary Blamire, *Richard Wilton: A Forgotten Victorian*, (London, 1967) p.109.

[95]Wilton pp.99-100

[96]A sturdy cotton fabric.

[97]Meyer p.97

[98]Wilton p.99.

[99]Webster p.15.

[100]*Line Upon Line Volume One* (1837).

[101]Author's apology *Peep of Day*.

[102]Meyer pp.66-7.

[103]These were single sheets printed with the alphabet in upper and lower case letters, the vowels and sometimes the Lord's Prayer. They were mounted on a board or stone and covered with a sheet of transparent horn or mica for protection against wear. There was usually a handle to hold the "book" and a thong or ribbon so that it could be attached to the child's girdle or hung from the back of a chair. A horn book provided no assistance in the puzzling task of relating the sounds of words to the patterns of letters.

[104]Mrs Honoria Williams's *Syllabic Spelling, or a Summary Method of Teaching Children to Read, upon the Principle Originally Discovered by the Sieur Berthaud, and Adapted to the English Language* had reached a fourth edition by 1828.

[105]Published in 1857.

Chapter Six (1834-1836)
Favell's Circle

Gaps were appearing in the circle of Favell's friends as the girls with whom she had worked at Belmont married and took up their duties in other places. Helen Johnstone[106] was now married and Favell went to visit her and her husband, Mr Craig, at Ryde on the Isle of Wight. She also kept up her correspondence with Mary Hall.[107] Belmont continued to welcome a stream of interesting visitors. The Brethren missionary Anthony Norris Groves (1795-1853), for example, came to stay after his epic missionary journey (1829-1832) to Baghdad. He had been accompanied on his missionary travels by his two boys who returned with him safely to England, but he had seen his wife and his baby daughter die of disease in distant Baghdad. Also on the journey was John Kitto (1804-1854), a deaf, dumb and partly physically disabled man whom Groves had rescued from deep poverty and who turned out to be an outstanding literary genius. Amazingly, given the nature of his disabilities, he was the boys' tutor during their travels and he went on to write a very popular *Pictorial Bible* as well as many other scholarly works. In her journal, Favell noted the story of Groves' wooing of his second wife. She had at first refused him, but he proposed to her again after she had been disfigured by an accident in which her face was crushed by a wagon in a narrow Devonshire lane.

Favell was living in times of great change. The arrival of the railways opened up new possibilities. Now the country could be explored in a manner that was unheard of in the past when to travel just from Belmont to Fosbury meant a journey of several days made up of short stages in the family coach. Suddenly, there

was easy tourism. Favell was as keen to enjoy the new experience as anyone else and in 1836 she set out with her young brother Barclay on an energetic tour of the north of England and Scotland, distant places previously out of comfortable range. But it was a tour with a difference. Favell and her brother took in evangelical preachers, missionaries and others along their entire route as well as the more usual attractions such as Treak Cliff Cavern,[108] Fountains Abbey,[109] the Scottish lochs, the Lake District and Scale Force.[110]

The London and Birmingham Railway had opened three years previously so Favell and her brother were able to go by train from Euston to visit Dr William "Millennial" Marsh (1775-1864) in Birmingham. Unlike some of the wilder proponents of premillennial ideas, Marsh seems to have been a very mild and gracious man. "There would be no controversy if the prophetical people were all like him," wrote Marsh's friend Charles Simeon.[111] After hearing Dr Marsh, they went on to visit the Rev (and Mrs) Theodore Dury (1788-1850) at Keithley in whose family Favell had earlier settled Louisa Aschel's sister, Tracey. The Durys seem to have been in the middle of a revival in the area as God blessed their energetic gospel witness, especially among those addicted to drink. Favell and Barclay's visit included an invitation to join the children of Keithley at a school feast.

In Edinburgh, they heard two preachers later to be prominent in leaving the Church of Scotland at the "Disruption," Robert Smith Candlish (1806-1873) who, according to Favell's journal, "read an oration of a flowery nature," and Dr Robert Gordon (1786-1853) likewise destined to become one of the leaders of the Free Church – and who was also the inventor of a self-registering hygrometer.[112]

Next, it was Dunkeld where in the Abbey Church they heard an excellent sermon on the ten virgins. Then it was back down to Carlisle where they heard John Fawcett, (d.1851) the perpetual curate of St Cuthbert's (Hatchard published his sermons), yet another Church of England evangelical associated with Charles Simeon. He preached from James' Epistle "Let the brother of low degree rejoice in that he is made low." Mr Fawcett told his

congregation to value "the permanent nature of heavenly riches, whilst those on earth are like a borrowed property, revocable at will."[113] After that they took in the Lake District where the principal attraction was the home of Mr and Mrs Carus Wilson. The Carus Wilsons lived at Casterton Hall dubbed, "The Evangelical Hotel" by the hymn writer Edward Bickersteth (1786-1850) for its constant popularity with visitors.

The Rev William Carus Wilson (1791-1859), founder of *The Children's Friend* magazine, is such an interesting character that it is worth pausing to study him in more detail. Favell had met his father, the friend and biographer of Charles Simeon, four years earlier when staying at her Uncle's home in Norfolk over Christmas.[114] She was clearly very fond of William and Anne Carus Wilson and family (five daughters, three sons by 1836 and a governess) and was convinced that they were doing an enormous amount of good with their Clergy Daughters' and Servants' Schools. The Rev Carus Wilson had been converted under the ministry of John Fawcett whom Favell and Barclay had just heard at St Cuthbert's Carlisle[115] and Anne Carus Wilson had been "greatly impressed" as a girl by the Christian witness of a family nurse. Favell described the Wilson's girls as "bright" and very much enjoyed the "lively family circle."

But a cloud hangs over Mr Carus Wilson and especially over his Clergy Daughters' School. One person at least did not think of him as a kind and benevolent minister bent on doing good to the poor and especially to poor children. Just over ten years before Favell's visit, the eight-year-old Charlotte Brontë had been sent to the Clergy Daughters' School and she had hated every minute of it. Later she was to blame the harsh treatment meted out to her sisters and herself at the hands of Mr Carus Wilson and his staff for the early death from tuberculosis of her sisters and for her own poor health. Worse still, in 1847 in her first published novel *Jane Eyre,* she would depict Carus Wilson, in the person of Mr Brocklehurst of Lowood School, as cruel, proud and hypocritical. It is hard at this distance in time to know the truth about Carus Wilson. When *Jane Eyre* was first published, he threatened the publisher with a libel action and as a result Charlotte Brontë

wrote him a letter explaining that she had used literary licence, exaggerating and embellishing for effect. This he never published, perhaps realising that if he were to acknowledge publicly that this rather uncomfortable cap fitted, he would have to wear it. In private, Charlotte Brontë continued to maintain her opinion. Reading Carus Wilson's *Children's Friend* magazine certainly gives a picture of someone zealous to do good. Although the gruesome emphasis on death and suffering repels modern readers, it is not unusual by Victorian standards.[116] Carus Wilson was clearly driven by the very urgent need to reach children with the gospel in an age of high childhood mortality.

Perhaps Carus Wilson had that gloomy and joyless kind of Christianity which cannot enjoy God's beautiful gifts for fear of worldliness. On the other hand, Favell's use of the words "bright" and "lively" in connection with his family would seem strange if that were the case. Or did Brontë, in her angry reaction against evangelical Christianity and all that it stood for, caricature him unfairly?

There are many parallels between Favell and Carus Wilson. Like him, she was a tireless writer for the young who preferred true accounts to fiction. Although she never resorted to the prodigious number of horror stories that he did, she was not afraid of plain speaking when it came to death and hell. She, like him, established schools and all her adult life she was involved in rescuing and adopting children from Louisa and Tracey Aschel onwards. Like Carus Wilson too, she saw all this as a means to an end – the salvation of souls – not just education and the alleviation of poverty. But the nagging question remains: if the Carus Wilsons *were* hypocrites was their friend Favell tainted with the same hypocrisy?

A reassuring answer comes from an unexpected place. There is a parallel figure to Charlotte Brontë, who vilified Carus Wilson, in Favell's life: Louisa Aschel, the rescued beggar girl. In 1860, Favell was to receive a letter from Aldinga, South Australia where Louisa and her husband Gabriel Cox had settled in about 1845. There they had prospered, becoming leading figures in the community and donating land for the construction of a Methodist church.

"It is with a heart full of gratitude to you, and I trust of love to God for His mercy to me, unworthy sinner, that I am spared..." wrote Louisa, "I trust I have sought and found the Lord... I am happy to tell you my husband is seeking the Lord, and we both feel we can trust our souls to Christ..." Later she wrote, "I have been telling my child how you used to take us in the shrubbery and try to lead us to Jesus as the friend of sinners. These lessons I have never forgotten."

Did anyone ever write in this vein to Carus Wilson? The contrast with Brontë could not be stronger. But where did the true difference lie? Was it the humble Louisa and the famous Charlotte who formed the contrast or Favell and Carus Wilson themselves?

The next point of interest for Favell and her brother was Knaresborough in Yorkshire, but Barclay probably left Casterton with some reluctance: Carus Wilson's daughter, Agnes, had become his fiancée and it was planned that when they married Barclay would become curate to her father. However, he managed to tear himself away and they travelled on south-east through the Yorkshire Dales.

At this time Knaresborough was in the throes of the most unusual revival imaginable. Mrs Maria Stevens (d.1840), sister-in-law to the Vicar, Mr Andrew Cheap, had found that adults, both men and women, flocked to the week night classes she conducted, although they were originally intended for children. Many conversions followed and Mr Cheap, far from stopping her "preaching", protected her from criticism and encouraged her to go on. Knaresborough was only three miles from the popular spa town of Harrogate, and spa visitors were soon making their way to observe Mrs Stevens in action too. By the time Favell and Barclay arrived in Knaresborough, she was something of a phenomenon – a celebrity even – and they probably went there expressly to hear her in her "crowded schoolroom." Mrs Stevens, simply dressed, and with a countenance "full of thought" began by singing "beautifully" to her own accompaniment and then: "... spoke for more than an hour on Eph[esians] v. Her fluency was wonderful, her discourse like a poem in manner, but in thought and substance worthy of a philosophical thesis."[117]

The Primitive Methodists and others had allowed lady preachers for some years. The thing that made Mrs Stevens different, and in fact made her into something almost of a circus act, was her connection with the established church. Favell herself was used to teaching and telling the gospel to children and women and one wonders what she would have done in Mrs Stevens' circumstances. Certainly she never felt called to imitate her; the humility that made her hide her name from her readers would have shunned the notoriety of a Mrs Stevens.

And so to Liverpool, presumably *via* the Liverpool and Manchester Railway, although the 70 miles from Knaresborough to Manchester must have been covered by road since the railways would not link Leeds, let alone Harrogate, to Manchester for another three years. Dean M'Neile, perpetual curate of St Jude's Liverpool, with whom they breakfasted and enjoyed family prayers at the end of their tour, was reaching the height of his powers in 1836. A tall energetic man with a very vigorous preaching style he later had a specially constructed pulpit at St Paul's Princes Parkway with springs and padding so that he could throw himself about while preaching without falling out. To the end of her life he was a hero of Favell's. He was of a similar age to her and, like her, before his conversion he had gone to Paris where he had seen François Talma acting. Some said his dramatic preaching style was modelled on the acting profession. He had been involved with Edward Irving and Henry Drummond but had parted company with them as they became more bizarre and unorthodox and the experience left him with a horror of charismatic Pentecostalism ever afterwards. A stalwart enemy of "popery" in all its forms, M'Neile was apt to be carried away in the pulpit, speaking from the heart, sometimes without thinking, sometimes without even knowing what he had said! But he was ready to retract his words if need be afterwards. Later (1850), in one famous incident in the morning service, he actually called for the death penalty to be enacted for anyone holding a Roman Catholic Confessional. When he was told afterwards what he had said he could not recall saying anything of the kind, but he went into the pulpit the same evening and solemnly recanted the remark. Over breakfast, Favell and Barclay asked his opinion of Mrs Stevens. He commended her theology highly[118] but Favell records no other comment.

And so home. And probably without the convenience of the railway at least in part because it would be another year before the Grand Junction at Warrington would open, allowing direct travel from Liverpool to London. Did Belmont and Fosbury seem dull after all the travel?

In 1836 Favell's favourite brother, Robert, married. He had been converted under the preaching of Baptist Noel at St John's Bedford Row and Favell's own witness had been influential in his change of direction. Her sister Frederica[119] married in the same year and so, of course, did Barclay. Henry Manning came to stay at Belmont with his "sweet and delicate [consumptive] bride"[120] Caroline.

Mary Hall became engaged. This was a blow to Favell! Now she was going to lose her most intimate friend because her husband to be was in the Indian Civil Service.[121] All her brothers and sisters and friends were marrying....

As a young person Favell had been disappointed that she had not found a husband by attending balls and assemblies. Henry Manning too had been denied her. Was she now contented with a life of single usefulness? Perhaps.

Endnotes

[106]See Chapter 2.

[107]See Chapter 2.

[108]Show caves in Derbyshire which are the source of the beautiful Blue John stone.

[109]A ruined Cistercian monastery in Yorkshire about ten miles from Harrogate.

[110]The highest waterfall in the Lake District.

[111]Charles Simeon quoted in Prime, Derek, *Charles Simeon*, (Leominster, 2011) p.221.

[112]An instrument used for measuring the moisture content in the atmosphere.

[113]Meyer p.73.

[114]See Chapter 3.

[115]See above.

[116]The Fairchild family's adventures for instance include a harrowing account of the sights and even the smells the children encountered when going to see a corpse laid out awaiting burial.

[117]Meyer p.74.

[118]Her *Scripture Doctrines Illustrated* was published before 1837. M'Neile is unlikely to have heard her himself but presumably had read the book.

[119]Here is a positive indication as to Frederica's spiritual state as her husband, Earnest Augustus Stephenson, (1803-1855) was on the London City Mission Committee in 1839.

[120]Meyer p.61. Caroline died in 1837.

[121]They married in 1838.

Chapter Seven (1836-1841)
Mr Mortimer

When Favell's brother Robert married Lady Agneta York[122] in 1836, their father bought Trent Park, a mansion not far from his home at Belmont for the couple. Rumour had it that the purchase at auction was accidental and he bid by nodding his head but was actually asleep! The Bevans (at Belmont and Trent Park), and the Bosanquets (Favell's sister Louisa and her family at Osidge) were now all living near each other, but there was still no evangelical Church of England ministry nearby. What should they do about it? Robert took the lead and together they adopted the then usual solution of well-to-do Anglican evangelicals in this predicament: they built a new church themselves. This was Christchurch, Trent Park, now known as Christchurch, Cockfosters, which, with the addition of later stained glass and some extensions, still stands today. Trent Park too is still standing but has suffered so much alteration that it is doubtful if Robert and Agneta would recognise it.

Together the Bevan family selected the minister for the new church with great care, eventually lighting on a Canadian gentleman, Rev Gilbert Lester Wiggins (c.1796-1872). Mr Wiggins had been compelled to come to England because his health had been badly affected by the harsh winters of his vast parish of Westfield, Nova Scotia with Greenwich, New Brunswick. This straddled the Bay of Fundy and was some 240 square miles in extent. Whatever visits he made to his parishioners must have been physically exhausting and potentially dangerous.

In 1838 the new minister preached his first sermon from 2 Corinthians 4:7 "We have this treasure in earthen vessels, that

the excellency of the power may be of God, and not of us," and his ministry was greatly appreciated. Favell's mother found it so helpful that she took to leaving the church at once at the end of the service and hurrying home to Belmont on foot so that she was not distracted by anything that would cause her to forget the sermon. But alas, Mr Wiggins' health did not improve and he became too weak to preach more than one sermon each Sunday. The Bevans had to cast around to find someone else who could take at least one of the services for him. They were very grateful when the Rev Thomas Mortimer agreed to help them out.

The Rev Thomas Mortimer (c.1785-1850) was a widower and the minister of the Episcopalian Chapel in Grays Inn Lane. How he came to be in that position is interesting and several features of the story shed a light on his character, on his relationship with Favell and on the difficulties that beset him for the rest of his life.

New Providence Chapel, Grays Inn Lane had been built originally for an eccentric but popular preacher, William Huntington (1745-1813). Opinion was, and still is, divided over Huntington. Rowland Hill at Surrey Chapel, on the opposite bank of the Thames, disapproved of him. His disapproval was so strong that when Huntington wrote to him he deliberately consigned the letter to the fire unread in the presence of the messenger that delivered it. On the other hand, William Romaine (1714-1795), fellow member with Charles Simeon of the Eclectic Society and minister of St Andrews by the Wardrobe near St Paul's was a warm supporter, "God raises up such men as John Bunyan and William Huntington but once in a century," he wrote. Huntington was a "high Calvinist" (his enemies accused him of being antinomian[123]) and given to visionary experiences but, although characterised by some as ignorant and overbearing, his preaching was associated with the revivals documented in J. H. Alexander's *More than Notion*.[124] Huntington came from the working class and had been a coal heaver. His original chapel, Providence Chapel, had been destroyed by fire so his congregation financed the building of the Grays Inn Road Chapel to meet their need for new and larger premises. The congregation then gave the new chapel outright to Mr. Huntington. When Huntington died, the chapel continued

with various ministers supplying the pulpit until it was bought in 1836 from Huntington's estate (which was in chancery) by an even more eccentric character, George Davenport of Paradise Row, Stoke Newington, a friend, ironically, of Rowland Hill.

George Davenport was very rich. Unfortunately, in 1838 a commission of lunacy, in a very high profile inquiry, declared him insane. A principal feature of his insanity (there were others[125]) was that he gave away all his wealth and property to religious causes. Prior to the commission's findings, he had given the Gray's Inn Road Chapel to Mr Mortimer enjoining him to turn it into a kind of theological school that would train up evangelical preachers for the Church of England. At this time, Mr Mortimer was minister of the district church of St Mark's, Myddleton Square, Islington. He had had a difference of opinion with the churchwardens (possibly about a political sermon he preached during an election) and had either already left or wished to do so. It is at this point that there is a first glimpse of his character although, tantalizingly, not of his reasons for falling out with the churchwardens.

"He is a man who from constitutional temperament is impatient of contradiction or opposition; and he met with enough of both, or imagined he did so, in... [St. Mark's], to make him desirous of having a chapel of his own, in the management of whose affairs he should not be interfered with, far less thwarted in any of his wishes," wrote James Grant in his guide to current pulpit styles.[126]

Grant continues with a detailed description. This gives the impression of a very popular preacher with an outstandingly powerful voice but with perhaps not a great deal of intelligence and certainly little sensitivity. Grant also noted an increasing tendency on Mortimer's part to move away from his earlier position of co-operation with dissenters (for instance in the London Missionary Society) and to become less willing to work alongside those outside the Church of England. Grant describes him as mildly eccentric. He notes that although it was common for stenographers to take down the sermons of popular preachers as they preached them and then publish them, Mr Mortimer hated the practice. Mortimer was certainly very keen that no sermon of

his should be published before he had personally corrected it for the press. The following note (reminiscent of the familiar words on a Lea and Perrin's[127] sauce bottle) was affixed to one of his published sermons. It gives us the peppery flavour of the man:

> N.B. this discourse was taken down in shorthand by Mr. HARDING, with my permission; and has been by me corrected for the press. Many of my Sermons having been surreptitiously obtained, and dishonestly published without any permission from me, either asked or given, I take this opportunity of saying that I cannot be held answerable for any printed Discourses to which I have not myself affixed, (as I do to this Sermon,) my name and residence.

> THOMAS MORTIMER, B.D. Mydleton Square, Pentonville, August 17th 1837[128]

New Providence Chapel as originally constructed was of the plain box-shaped type favoured by dissenters and designed principally to give the best acoustics for preaching. Once the chapel was taken over by Mortimer, work was put in hand to beautify it in the early nineteenth century Church of England style. A newspaper report of the time says:

> The interior of the chapel, which appears to be of dark oak, carved in the richest and most graceful manner, is a perfect gem of architectural beauty; we have seen nothing like it in any of the new churches of London; and we do not remember to have seen in any building, new or old, the highest degree of luxuriant ornament, so perfectly reconciled with harmony of ensemble, and chastity of general design. We would advise artists to give a day to the contemplation of the richly-fitted chancel.[129]

This was certainly a contrast to the plain interior of the building in Huntington's day. No less a contrast to the old order of things was Mr Mortimer himself. Samuel Palmer in his *St. Pancras* explains that the refurbished chapel:

> ...was opened by Mr. Mortimer as an Episcopal chapel

[Huntington was an independent], by two sermons, that in the morning by the Vicar,[130] and that in the evening by himself, in which he most indecorously referred to his 'coalheaver' predecessor, and bitterly inveighed against non-episcopal [i.e. dissenting] preaching.[131]

The Morning Herald April 3rd 1837, in its report of the opening, hints at something of the character of Mr Mortimer's remarks:

The chapel which has thus been added to the establishment, was, as most of our town readers know, erected towards the close of the last century, by or for... William Huntington, better known by the name of the "coalheaver saint," who used to boast that his inward man was fed, and his outward man clothed, by the special interference of the Almighty. If there were any persons among the congregation assembled yesterday who recollected this Huntington, what a contrast must have been presented to their minds between the beautiful service of our church and the ridiculous vagaries formerly enacted in the same place...

A very homely letter, mis-spellings and all, is sneeringly reprinted at the end of the article to drive home the point about Huntington's ignorance.

Ironically, although old Huntington may have been uneducated,[132] Mortimer himself was hardly an intellectual and if Huntington was proud and obstinate, these were failings which could also have been laid at Mortimer's door. Perhaps, despite their differences, the old and the new incumbents of the Grays Inn Lane Chapel were not so dissimilar after all!

Unfortunately for Mortimer, his move to Grays Inn Lane Chapel was to be the beginning of deep financial troubles that oppressed him for the rest of his life. Initially, the chapel was crowded to capacity (which in those days of pew rents[133] meant it was profitable) and the additional cost of the "dark oak, carved in the richest and most graceful manner" etc. would no doubt quickly have been met. Mortimer was a popular preacher and many of his

congregation may have followed him from St Mark's. However, in view of Mr Davenport's lunacy, it was ruled that his gift of the chapel to Mr Mortimer could not stand and that Mortimer would have to either buy or rent it from Mr Davenport's trustees. In the Dickensian wrangle that followed, Mortimer fought the case, arguing that the gift had been made *before* Mr Davenport had been declared insane, but he lost. Meanwhile the chapel was so popular that in order to prevent the various difficulties that began to arise from there being far more prospective auditors than seats, the gates leading from the road to the chapel were shut after the service had been in progress for half an hour. Apparently this put people off, despite the fact that Mortimer was one of the shortest sermonisers of his day – half an hour and the whole service only one and a half hours. Congregations, and therefore pew rents and "gratuities,"[134] began to dwindle. This was a financial disaster since Mortimer now had to rent (or buy) the chapel from Davenport's trustees and finance the elaborate decorations while the income needed to do this was diminishing.

It was at this point that Mr Mortimer came to the Bevans' assistance by driving down in the afternoon to Trent Park, taking the service there and then returning to town in time to take the Grays Inn Lane Chapel service. He was obviously not only motivated by unselfish generosity; he would have been paid and he was in considerable need of money.

Favell had already met Thomas Mortimer at a Church Missionary Society meeting in 1839 at nearby Southgate, where he spoke. Later her journal describes him as a "striking preacher, though not so judicious a divine as Mr Wiggins."[135] She sent him some of her little books as a thank-you present for his help at Christchurch, noting that he was a "godly man, though not one of judgment."[136] How much did she know about his background? Was her perception of him as "not so judicious" and lacking in "judgment" a reference to his criticism of Huntington or just the opinion she formed of his preaching? Certainly there was enough evidence available to make her cautious if she had only taken the trouble to look for it.

Mr Mortimer was invited to spend an evening at the Bosanquets' home at Osidge. He was asked to address the children and servants who were all assembled for the purpose. Here Favell learned that he had "begun to serve God when he was five years old, that he had first learned to pray during a thunderstorm, that he had never joined in worldly society and had never entered a theatre." Whether he mentioned all this in the course of conversation with the family or as part of his address on Luke 2:52 is not clear. Some weeks later, he visited Belmont with his daughters Mary and Harriet. He was there to visit Barclay but Favell, coming in from her morning school, bumped into him and his daughters in the library. She made a deep impression on him.

Life for Favell continued in its usual channels, at least on the surface. She corresponded with Mary Hall (now Mrs Morris) in India and sympathised with her over the death of her infant son. Mary sent Favell a letter from Chittagong,[137] where her husband had been appointed special commissioner, describing a little group of Baptists who met in a small chapel "in one of the valleys" there. Felix Carey (1786-1822), the tragic son of pioneer missionary William Carey (1761-1834), had been the first missionary to go to Chittagong so perhaps this was a group of converts dating from his time.

Favell visited Fosbury, travelling now for most of the way by train. As ever she enjoyed the company of Lizzie (Betty had died) and of Sarah Farr. Then she paid another visit to Casterton Hall where she had much and varied Christian fellowship before returning home to Belmont. Did she discuss Barclay's friend Mortimer at all with Barclay's father-in-law Carus Wilson?

Favell's mother was gradually declining in health at this time and was probably in considerable pain. Treatments for the ulcerated uterus from which she suffered were at this time painful and liable to make the condition worse by the insertion of pessaries to support the associated prolapse, increasing the ulceration and leading to further infection. Sufferers usually became very weak and unable to get out of bed. It is no surprise therefore to read that "a visit to London with medical treatment there did but

aggravate the pain," and that she "continued to decline without intermission."[138]

It was while Mrs Bevan was in such poor health that Thomas Mortimer proposed to Favell and she accepted him. He called to see Favell at her Belmont schoolhouse where "he entreated her so passionately to accept him that she consented."[139]

There was something strange about Favell's relationship with her husband. Her nephew Edwyn Bevan (1870-1943) went so far as to claim:

Mr Mortimer had a violent temper and sometimes treated his wife with cruelty. On one occasion, at any rate, she took refuge in my father's house [R C L Bevan's Trent Park] declaring that she could not go back to Mr Mortimer, though in the end, I think in consequence of my father's representations, she decided to do so.[140]

Edwyn Bevan only knew his aunt as an old lady when he was a very small boy. Mr Mortimer had been dead for twenty years when Edwyn was born. His own father, Favell's brother R C L Bevan, died when Edwyn was twenty in 1890. Edwyn is, therefore, relating family memories of an incident and a relationship of which he had no personal knowledge and about which his father is unlikely to have talked to him. The only other family member who mentioned trouble in the marriage is Edwyn Bevan's sister who is merely echoing her brother's remarks.[141] Favell's earliest biographer was her niece Mrs Louisa Clara Meyer (neé Bosanquet) who was born much earlier in 1826. She knew her Aunt *and* Mr Mortimer well but never hints at any trouble between them. By the time of Favell's marriage she was already helping her aunt in the Belmont school and seems to have enjoyed a very close relationship with her. If there was any trouble, she may not have mentioned it in her book to avoid damaging Favell's reputation in particular and that of the family in general. But Mrs Meyer quotes extensively from Mr Mortimer's sermons and prayers, dwells on his sufferings in illness and in the loss of his daughter

and generally presents him in a favourable light. This she would surely not have done if she had been aware that he had mistreated her much-loved aunt.

Favell was not young and inexperienced as she had been in the days when she had been involved with Henry Manning. Perhaps she flattered herself that she could make a cool assessment both of Mortimer and of herself. What did she see in him then? His appearance according to Grant, though commanding, does not sound attractive:

> Mr. Mortimer's personal appearance is very striking. He is of a large muscular frame of body, and evidently of a strong constitution. Though under his fiftieth year, his hair, which is exceedingly short, is of so light a grey as to approach a perfectly white colour. His eyebrows, which are very large, give to his face a peculiar appearance, owing to their being dark, while the hair of his head is white. His face is large and of the oval shape. His features generally are prominent. His mouth, which exceeds the average dimensions, appears larger than it is when speaking, owing to his opening it wider than most speakers do.[142]

This is not exactly winsome but then Favell's first impressions were definitely mixed. It is possible that in the pulpit he reminded her somewhat of her great hero, Dean Hugh M'Neile, who was a dramatic pulpit orator and well over six feet tall. Like Mortimer, he had a very powerful voice and his pulpit gestures were theatrical. Like Mortimer, he too preached extempore (fairly unusual at this time in the Church of England) and was given to making remarks in the pulpit that were ill-judged or worse. But if there was in Mortimer a resemblance to M'Neile in volume and fearless offensiveness, it was very superficial. For all his faults, M'Neile was generous, warm hearted, co-operated with protestant dissenters, loved the Catholics themselves while loathing their beliefs and (as already noted) was even prepared to publicly apologise when he went too far.[143] One cannot imagine Thomas Mortimer doing such a thing. Certainly his harsh remarks about old Huntington were never withdrawn.

Mrs Meyer hints that Mortimer's debt ridden condition on account of the chapel was the reason why Favell's parents (or was it Favell's sister, Louisa, Mrs Meyer's mother?) counselled her to be cautious. There may have been other reasons that Mrs Meyer does not mention and perhaps did not even know of. At any rate Favell, so dutiful in her obedience when it came to breaking off her correspondence with Manning, seems to have put her foot down over Mortimer.

Favell was a very thoughtful and sensitive person with a great capacity for friendship and a great love for and understanding of children. She was an excellent teacher and a very well-educated woman herself. Her husband was very different. Grant remarks that he never went up to Cambridge but studied under a private tutor at home[144] because his father considered, "his flow of spirits was so great" that "there would be so many objects to divert his attention" at Cambridge and he adds that those that knew him would readily believe this to be the case.[145] Whatever Thomas Mortimer's Royal gun-maker father meant by this strange remark, surely it was not that Thomas's brain, brimming over with intelligence, would drive him to spend his time questing after knowledge in all its branches in Cambridge instead of concentrating on divinity. Mortimer rather gives the impression of a person who finds it hard to learn because he cannot bear to be corrected or contradicted.

So did Favell marry him thinking she was getting a larger than life, bluff man, a natural leader, outspoken perhaps, but fair minded? Did she find when it was too late that she actually had a stubborn, loud and small-minded husband who could not be persuaded or put right over anything and who would not tolerate being thwarted in any of his wishes? With Manning, she had delighted in the role of teacher, spiritual guide. There was no room for this at all with Mortimer. She was a dedicated teacher: he was unteachable. Perhaps then the "cruelty" which Edwyn Bevan mentions was not physical but rather mental in that she found him insufferable and, in his pig-headed denigration of people, even those she held dear, crushing.

Endnotes

[122]She was Lady Agneta before her marriage and retained the title.

[123]Believing that since the Christian's sins are forgiven, he is not bound to keep the moral law.

[124]London 1964.

[125]According to the *Annual Register, or a View of the History and Politics of the Year 1838,* his servants gave evidence to the Commission of Lunacy that he wandered about the town in the small hours leaving his distressed wife searching for him and that he insisted that the water-closet be removed from his house because it was "an abomination unto the Lord."

[126]Grant, James, *The Metropolitan Pulpit; Or Sketches Of The Most Popular Preachers In London,* (London, 1839) p.233.

[127]Messrs Lee and Perrins first marketed their famous sauce in 1837. The bottles are still marked "none genuine without this signature."

[128]Harding, W, *The Church of England Preacher or Sermons by Eminent Divines, Delivered in 1837,* Vol. 1. p.28.

[129]Undated newspaper cutting pasted into the British Library's copy of *A Catalogue of the ... furniture, ... books ... and various other effects, the property of ... W. H., dec. ...; which will be sold by auction, etc.* 1813. General Reference Collection DRT System number 016793099.

[130]James Moore, LL.D. Vicar of St Pancras from 1814 to 1846.

[131]Palmer, Samuel *St. Pancras* (London, 1870) p.114

[132]His writings clearly show him to have been intelligent and witty, however.

[133]Although some pews were usually reserved for those who did not pay, most were rented in order to provide local finance for the church. This practice was adopted in both established and dissenting places of worship.

[134]Sixpence at the gate to enter the service for those with no rented pew.

[135]Meyer p.88.

[136]Meyer p.89.

[137]Now in Bangladesh.

[138]Meyer p.94.

[139]Meyer p.98.

[140]Bevan, Edwyn, "Peep of Day: A Lawgiver in the Nursery", *The Times,* June 27th 1933.

[141]Webster p.16.

[142]Grant, p.243.

[143]See Chapter 6.

[144]He began his training by staying with his half brother George Mortimer who was curate of Madeley, Shropshire from 1815 to 1825. This may be what Grant means by "at home."

[145]Grant, p.232.

Chapter Eight (1841-1849)
Mrs Mortimer

Favell and Thomas married in April 1841; she was thirty-nine. The dying Mrs Bevan had given her blessing, "You will be blessed, you must be blessed," she said, "I cannot forget the course you have pursued for fourteen years, [i.e. since her conversion in 1827] how with a single heart you have served the Lord, and with how much effect upon others."[146] What her father thought is not recorded but it is strange, and perhaps significant that Favell did not get married at Christchurch, Trent Park. Although she certainly did not "elope,"[147] as one of her nieces wrote, she did go to the "Evangelical Hotel" for her wedding which took place at Casterton, William Carus Wilson officiating. A close friend from Wanstead, Miss Paris,[148] went with her but no one from the Bevan or Bosanquet families accompanied her up to Casterton as far as is known from surviving accessible records. Also not recorded is who gave her away. It is possible that Barclay Bevan, by now vicar of Skirton, Lancashire fifteen miles from Casterton, did so. Certainly Mrs Meyer relates that Barclay, "loved her [Favell's] husband with no common affection,"[149] but her silence in this regard with respect to other members of the Bevan family makes one suspect coldness.

The couple spent an extended honeymoon at Windermere and Fosbury. At Fosbury, Mr Mortimer preached to a packed congregation, presumably in the little schoolroom, and "a deep impression was made on many hearts."[150] Not long afterwards, a Fosbury farmer made the journey to the Grays Inn Lane Chapel to tell "what a change had been made in his mind and in that of his neighbours by Mr Mortimer's addresses."[151]

Favell and her husband returned to his home at Fortis Green, Finchley to begin married life in earnest. On Sundays, they spent the day at the Grays Inn Lane Chapel and Favell was given the job of teaching the twenty choristers, although it is not clear whether this was a Sunday occupation or a week day one.

Back at Belmont, Favell's mother's health continued to decline and she died in August. At first she thought that the excruciating pain she suffered was sent to her as a judgment. Mr Wiggins seems to have been exactly the right person to help and reassure her. He did not point to all the good she had done or her saintly behaviour: this would have made such a sensitive person feel more than ever that she was a hypocrite. Instead he said, "there is no anger in the rod with which God chastises His people," and encouraged her with a simple sermon on the text, "Believe in the Lord Jesus Christ and thou shalt be saved." She died in great pain and also in great peace. Favell had now lost the only person in the family, with the probable exception of Barclay (who was far away in Lancashire), who had ever said anything encouraging about her marriage.

Favell was now step-mother to Harriet and Mary Mortimer whose mother, Letitia, had died in 1836. The girls had been sent away to school on Jersey, but in 1842 they came home. Favell seems to have been exactly the mother figure they needed. Stepmothers often have a difficult relationship with their stepchildren, but this was not the case for Favell. Here was a ready-made adoption for her and she loved the girls dearly. When Harriet caught influenza and both girls went to Ramsgate to aid her recovery, Mary wrote to Favell:

> I wrote to you before as an unknown being; I write now in confidence, and I love to look at the address of my letter to one we know and who, to the utmost of her power, will be our protector, counsellor, and guide. Each word of your letter only increased my gratitude to God for having left us motherless no longer.

There is nothing formal or stiff here and the letter breathes

genuine love and gratitude. Favell took the girls by train to Fosbury with Robert and his family and one can imagine how much they enjoyed this country retreat.

But Favell's happiness with her two new stepdaughters did not last. The older girl, Mary, became very ill and developed water on the brain from which she eventually died. Harriet also became ill and very depressed. She imagined that she had been the cause of her sister's death and her mental condition deteriorated to such an extent that she was unable to live at home and went to live "under medical care."[152] Favell, who loved to be with young people and children, missed them both. "You with your many children do not know the gloom which is apt to steal into a house where there is no young person to cheer the sight,"[153] she later wrote to her sister Louisa.

Harriet's personality was affectionate and endearing to her stepmother and they were clearly fond of each other despite the problems. She remained away from home with only one interruption until her father's death. She then remarkably recovered and lived a normal life, marrying a widowed upholsterer when in her forties. The word "protection" in Mary's letter, the nature of Harriet's illness and the timing of her recovery might make one wonder about the relationship between the girls and their father and about Favell's part in it. Did she champion their cause when their father mistreated them and suffer for it herself? This interpretation, is based on slender evidence but, however exaggerated or distorted Edwyn Bevan's claims of cruelty might be, if they had any basis at all in truth, this might be a possible explanation.

Through all this period Favell continued to write. *The History of Count Zinzendorf* and *Light in the Dwelling* date from this time. This last book is a harmony of the Gospels set out in the form of a year's daily readings; not for children but for family use. It forms a commentary on Bible passages selected to tell in sequence the life, death and resurrection of Christ and is designed to be read at family prayers after the passage itself is read. This is the only book Favell wrote for adults. The language is still very simple and

direct and the gospel message is firmly brought home in every day's section. Favell had in mind that the book might be bought for use by cottagers such as those she knew so well at Fosbury. She hoped that unbelievers, conscious that they ought to be having family prayers, would use it. The book explains Scripture passages just as *Peep of Day* and its successors had done for small children and there is an evangelistic emphasis throughout. Favell was cautious over taking this step into adult literature and modest as ever about her own name which, as usual, did not appear on the book. "Revised and corrected by a clergyman of the Church of England"[154] says the title page, making it clear that she, as a woman, was not making unsupervised theological statements or, as it were, preaching in print. There is a significant difference in attitude (as well as in language and style) here between Favell's book and Mrs Stevens' *Scripture Doctrine Illustrated*, but perhaps having heard Mrs Stevens in action emboldened Favell to produce her book.

Then, in 1846, came another unexpected family tragedy. Favell's father, David Bevan, rising as usual at breakfast time, went into the Belmont dining room where a cheerful fire was blazing. He sent the butler who acted as his attendant off to fetch something, put on his spectacles and began to read his post. A little later, the butler heard the agitated ringing of the dining room bell. He hurried back and found to his horror that his master was ablaze. Mr Bevan was standing up and the armchair in which he had been sitting was also on fire. The butler acted at once and sensibly threw him down onto the floor, rolling him in the hearth rug and some red floor covering to smother the flames. Then he rang the bell again as hard as he could to call for help. Other members of staff arrived quickly on the scene and a nearby doctor was called at once.

David Bevan had limited mobility and also difficulty in speaking because of his stroke. It was assumed that he had been standing with his back to the fire reading a letter and the tail of his cotton dressing gown had caught alight. Feeling the heat from this but unaware that his clothing was on fire, he moved away from the fireplace and sat down in his armchair, thus setting it

alight. He then discovered what had happened and struggled out of the armchair (getting out of a chair was difficult for him since his stroke) and had rung the bell. He himself took the accident calmly, giving orders that the armchair was to be repaired and walking to his own room.

The doctor considered the extent of the burns on the back, leg and arm very serious and the usual dressing of linseed oil mixed with lime water was applied to exclude air from the burnt tissue. Although he was faint and restless, Mr Bevan felt no pain because the nerve endings were burnt away, an indication that he had suffered what would now be classified as third degree or full thickness burns. The family were summoned. He began to suffer vomiting and prolonged hiccups – a sign that he may have had another stroke or even a heart attack. He was still able to communicate and sent various messages to members of the family. He asked what the doctors thought of him to which Louisa, "replied that he was in a precarious state, and spoke of the Saviour."[155] He asked for Barclay to come to read and pray with him but when he arrived he was too weak to bear this for very long. He asked Louisa several times, "How deep, deep, deep?" which sounds exactly like a stroke patient speaking. No one understood what he meant until he asked again, "How many feet deep?" when it dawned upon them, no doubt with horror, that he was asking about his grave. "Ten," replied Louisa's husband, quickly adding, "Do sir, look above, not below." Cared for in an armchair rather than in bed because he seemed more comfortable there, he sank into unconsciousness, dying on Christmas Eve.

Favell and her father had never been very close. It had been her mother rather than her father who had taught her as a child and who had given most of the advice and counsel, good and bad, that had moulded her youth. The loss of her mother had been a personal grief. The loss of her father was the loss of a family head. That rôle would now devolve upon her brother Robert. Favell and Robert had once been very close indeed. He owed much of the influence that led to his conversion to her. But would it be to Robert that she would now look for family guidance and what

kind of person was the new head of the Bevan family? It is worth side tracking a little to find out.

If there were any doubts about David Bevan's spiritual state, his son Robert's was crystal clear. Back in 1837, Henry Manning, not long after the death of his young wife, had paid Robert a visit. Manning reproached Bevan for going to hear Harrington Evans,[156] telling him that to listen to his Uncle George Bevan's old associate was a sin. He also told him he did not agree with Favell's "theological sentiments."[157]

"I do," replied Robert. This short statement carried with it great significance. Robert was pronouncing his *Credo* in terms that Manning certainly understood. It was Favell that had been Robert's "little Mama" when he was a baby, and who had written to him when he was at school, "Do you *ever* read your Bible? Do you ever pray? Do you swear? Do you tell untruths?" This letter, so typical of Favell in its blunt directness, influenced him to such an extent that he carried the worn fragment of paper around with him for more than fifty years, showing the memento of his boyhood to anyone who was curious.

Robert was a fearless rider and hunter. He and his brother Richard (who unlike Robert never did anything *but* ride, hunt and shoot) "were the best men to hounds in the Pytchley Hunt."[158] Robert had the distinction of being the only person, apart from William Frederick "Mad" Wyndham (1840-1866), who ever galloped down the steep-sided valley popular with Victorian tourists known as Devil's Dyke near his grandparent's home in Brighton. Such was his skill that he could "jump a five barred gate with a sixpence between each of his knees without letting it drop."[159]

But there was far more to R C L Bevan than exhilarating horsemanship. Years previously, when his father first became ill, he had taken his place in the bank. The other partners were his father's "old and tired"[160] contemporaries and he found himself running the whole concern long before his father's death. Perhaps his greatest service to the firm was on the first Black Friday, May

11th 1866. Overend Gurney, a bank with Quaker family origins and distantly related to the Bevans, failed and a panic started as a result. RCL unflinchingly advised the Bank of England not to lend money to Overend Gurney as their affairs were in such a state that no loan could save them. As repercussions from the failure spread to other banks, a menacing crowd gathered outside Barclays at 54 Lombard Street, demanding their money. RCL went out to the crowd and shouted, "Come and take your money away! Come and take it! It is all there!"

"His ringing voice and commanding presence [he was six foot three] had the effect of reassuring the crowd, which gradually melted away, and the panic was allayed."[161] Of course, it was not just his height and his hunting-field voice that persuaded investors that their savings were safe. R C L Bevan's standing as a well-known evangelical would also have influenced the crowd and they were right to trust him: he had in fact made arrangements with the Bank of England for support should large sums have to be paid out.

At the time of his father's death, RCL was married to Agneta York (1811-1851) to whom he had proposed not long after his conversion. As well as "riding recklessly about the country,"[162] he had been fond of dancing and theatre-going; presumably his mother had introduced him to these amusements along with Favell and her sisters. He gave them up on becoming a believer and Agneta, though brought up to them too, cheerfully renounced them. He married again after Agneta's death and his second wife Frances Emma Shuttleworth (1827-1909), though the daughter of a bishop, later joined the Brethren.

R C L Bevan was immensely rich – his annual income was in the top one per cent in the country. The uses to which he put it were extraordinary and varied. Still standing today in Oxenwood near Fosbury are the beautiful flint and brick houses with their large gardens which he built for the estate workers to replace their old insanitary and uncomfortable homes. He provided Fosbury with a church and parsonage, both of which remain. He watched over the interests of the tenants at Fosbury with a

firm kindness that was remembered with gratitude long after he had departed this life. He received a "flood of begging letters which poured in daily and to which he never paid a deaf ear."[163] He gave freely, deliberately not enquiring deeply into the cases that presented themselves because he said, "he would rather give to several undeserving amongst the many applicants, than miss giving to the *one* who really needed his help."[164] A great friend and supporter of his contemporary, Lord Shaftesbury (1801-1885), and very involved with the London City Mission, he often threw open the extensive grounds of Trent Park for treats and *fêtes*. Shaftesbury's shoe-blacks, and poor school children from schools run by Mrs Kinnaird (1816-1888), the founder of the YWCA, and Mr William Pennefather (1816-1873), the new rector of the Bevan's Christchurch, were all welcomed. "The tenth of his income he regarded as not his own at all, that belonged to God; the rest must be laid out for the greatest good of the greatest number," wrote one of his daughters.[165]

But the most telling insight into the roots of R. C. L. Bevan's Christian character comes from his own book *Accommodated Texts*, published in 1854. This consists of a selection of Bible texts which he considered were often quoted but misused or misinterpreted – "accommodated," as he put it, to ideas which the texts themselves did not teach. J. C. Ryle (1816-1900) later addressed the issue of accommodated texts in his *Simplicity in Preaching* (London, 1882) but RCL seems to have been the first, if not the only, person to devote a whole book to the subject. Following each text in RCL's book is a correct interpretation gleaned from minute and painstaking study of the texts themselves and their contexts alongside a careful perusal of a mass of commentators. R. C. L. Bevan's deep love of, respect for and knowledge of the Word of God is evident on every page. This, the only book he ever wrote, is not about philanthropy or even preaching but goes right to the heart of the Christian life: it is a plea for serious and exact Bible study.

Accommodated Texts shows that R. C. L. Bevan was very well-read and he quotes a galaxy of commentators, some quite obscure, in the course of what is little more than a booklet of fewer than eighty pages. No doubt the magnificent library of Trent Park,

like many a library in a grand house of those days, contained all these commentaries and more. RCL was unusual in putting his collection of books to such serious use. His concern for careful and nice use of language in understanding the Word of God might surprise us in one who was a banker and a fearless horseman and who had never even finished his university career. We would scarcely expect such a man to be bookish, but the influence of his early upbringing, of his mother, of Miss Clare and perhaps even of Dr Collison, the academic tutor, can been seen in the little book. But the greatest influence was that of his "big sister" Favell. "When explanations are made, great brevity is needed," she wrote to him when he was writing the book, "... [r]emember the four essential qualities of an opening sentence. It must be short, easily understood, interesting, and conciliatory."[166] She also urged him to include Hebrews 12 v.1 "Sin which doth so easily beset us," in his list of texts to be included in the book (he didn't). The tone is more "man to man" than that of Favell who always writes as if addressing children, but the same burning concern for the Bible, its promotion, interpretation, distribution and circulation motivated them both.

From 1884 until his death, Robert Bevan was one of the vice-presidents of the Trinitarian Bible Society. This was a change, perhaps even a natural development from the family's traditional support for the old British and Foreign Bible Society of which Robert Bevan's friend Shaftesbury was president until his death in 1885. The newer society was formed in 1831 when it became clear that the old society was prepared to circulate Bibles containing the apocryphal books and would allow Unitarians to be members. T.B.S., however, was dogged with problems at its outset as its original members included Edward Irving and his fellows. When Irving and his associate Drummond became more and more eccentric and extreme in their Pentecostal ideas, this naturally tainted the fledgling society. Eventually Irving drifted into a kind of Arianism – ironically one of the very heresies T.B.S., had been founded to combat. Dean M'Neile, who had been a founder of the T.B.S., along with Irving, actually went back to the old society when he saw the error of Irving's ways. When the T.B.S., was no longer associated with the "Irvingites" it was still a long time

before it could recover from the set back. In 1861 it was on its knees financially and nearly folded up altogether. It may be significant that R C L Bevan's public association with T.B.S., did not occur until the very end of his friend Shaftesbury's life. One can certainly imagine that at this crucial point Robert Bevan's financial support would have been very useful to the newer society.

Like Favell, RCL did not seek the limelight but there is no doubt that, like her, he was an immense force for good in the sphere in which God had placed him. His was a supremely generous Christian character. But this leads us to a puzzle. Robert could easily have relieved Thomas Mortimer, husband of his favourite sister, of the crippling debts from the Grays Inn Road Chapel that dogged his life and hastened his death. He did not do so. In the absence of available documentary evidence,[167] one can only conjecture the reasons. Had he told his sister plainly that he suspected Mortimer was marrying her for money to solve his debt problem and, to discourage her, made it plain that none would be forthcoming from him? RCL was a man of his word; his banking reputation rested on that fact. Was his failure to help financially a consequence of a rigid determination not to go back on what he had said?

Meanwhile, in the March following her father's death (1847) Favell received a letter from Archdeacon Manning. After offering his condolences, he asked about the letters he had written to her in the early 1830s. Were they still in existence? Would she be prepared to return them to him in exchange for those she had written to him?

"The voluminous correspondence between two such people so eminent in their different ways in after-life as Henry Manning and Mrs. Mortimer on the subject of personal religion and on religious belief could not have failed to be of singular interest,"[168] wrote Manning's first biographer and in view of the step he was contemplating, Manning may have felt it might be only *too* interesting if it ever got out! He seems to have been afraid lest these youthful outpourings should fall into the wrong hands. Manning was very close to his brother-in-law, Henry Wilberforce

and Henry's own brother, Robert Wilberforce. All three of them had rejected the evangelicalism of their fathers. All three were Church of England clergymen and all three despised dissenters as schismatic. Manning called dissent "mere disorder"[169] and considered dissenters were suffering from "the bondage of imperfect Christianity."[170] But this led to an inevitable question. On what grounds was the Church of England not schismatic herself? Suppose the only true church was really Roman Catholic? Many Tractarians contemplating a move to Romanism justified their decision on the basis of receiving three signs – any signs – which they considered were from God. Manning began to look for his three signs. If God showed by three signs that the Church of England was in schism, he would resign from his office in the Church of England and cross over to Rome.

Favell knew nothing of all this heart searching, although she must have been aware that Manning was a leading figure in the Anglo-catholic movement within the Church of England. She complied with his request for the letters. In the letter accompanying the correspondence he returned to her (and which she destroyed) he included an invitation to her to visit him when he was next in town. This she did and found him frail, thin and expecting to die. Their conversation was without any controversy and his gentle reproof of her because "[h]e thought her manner was not sufficiently serious,"[171] moved her to tears. She seems not to have suspected where his next move would take him.

In January 1849, a new and very significant character entered Favell's life. She and her husband were introduced to the young Lieutenant Lethbridge Moore.[172] "Lethbridge Moore had been taken out to India by his parents; when his father died the regiment adopted the eleven-year-old Lethbridge, and he marched along with them. The tiny rifle he carried was for a long time preserved by his family. Later on, a commission was purchased for him by officers who remembered his father. His career seemed plain before him when, in his mid-twenties, he returned to England on long leave."[173] Once back in England he was converted, perhaps through Mr Mortimer's preaching. Thomas Mortimer, it will be remembered, had had, since at least the days of the Davenport

debacle, a great desire to foster the training of young evangelical men for the Church of England ministry. The order of events is not quite clear from the surviving accessible records, but it seems that when Lethbridge expressed a desire to become a Church of England minister, the Mortimers adopted him with the object of helping him to obtain the necessary education for this purpose. Adoption was by now a leading theme in Favell's life. Louisa Aschel, flourishing in Aldinga, South Australia, was the first of her adoptees; Lethbridge Moore was perhaps the most personally important to her.

Lethbridge moved in with the Mortimers, resigning his commission and becoming part of the family, despite the fact that his mother (with whom Favell had an excellent relationship) was still living. That the Mortimers were prepared to take this step at this time was generous: Mr Mortimer was still entangled with the debts relating to the Grays Inn Lane Chapel and his health was beginning to break down under the strain. For Favell, there were great personal benefits to having Lethbridge join the family. Now once again she had some of the young company which she craved. Lethbridge revered Favell, supporting her through all the difficulties that lay ahead of her and referring to her after her death as "the dear Mother." She in turn treated him as the son she had never had, lavishing affection on him. "Though we did not adopt our son to promote our own pleasure, but the Lord's work, yet he does promote our comfort and make our hearth and table more cheerful every day,"[174] she wrote to her sister Louisa Bosanquet. No doubt Lethbridge's early education in India had been very deficient and certainly it was several years before he was ready for university. It seems likely that, at least at first, Favell taught him herself. Manning had rejected her teaching, Mortimer did not need it, Moore soaked it up with deep gratitude.

Endnotes

[146]Meyer p.99.

[147]Webster p.15. Mrs Webster was not born until 1875.

[148]Possibly a friend from Marsh Lane Chapel days as Wanstead is some way from Barnet but near Walthamstow, perhaps Jane Elisa Paris (d.1892) or one of her sisters.

[149]Meyer p.146.

[150]Meyer p.99.

[151]Meyer p.100.

[152]That is with a private doctor who ran a small asylum.

[153]Meyer p.141.

[154]Presumably her husband.

[155]Meyer p.125.

[156]Harrington Evans (1785-1849) Minister of John Street Baptist Chapel, Gray's Inn Road. See Chapter One.

[157]Meyer p. 79.

[158]Webster p.13.

[159]Webster p.13.

[160]Webster p.13.

[161]Webster p.14.

[162]Webster p.13.

[163]Webster p.34.

[164]Webster p.34.

[165]Webster p.35.

[166]Meyer p. 155.

[167]See the bibliography for an explanation of this issue.

[168]Purcell, Edmund Sheridan, *Life of Cardinal Manning, Archbishop of Westminster,* (London, 1896) Vol. 1. p.64.

[169]Newsome, David, *The Parting of Friends,* (London, 1966) p.200.

[170]Newsome, David, *The Parting of Friends,* (London, 1966) p.270.

[171]Meyer p.134.

[172]Lethbridge appears abruptly on the scene in the surviving available sources.

He may have been related in some way to James Moore, LL.D. Vicar of St Pancras from 1814 to 1846 who was a friend of Thomas Mortimer's from his days at St Mark's Myddleton Square; see Chapter 4.

[173]Wilton p.99. The author, Mary Blamire Young, from stories handed down in Lethbridge Moore's family, claims Favell adopted him when she was herself a widow and that she "was in love with him." This is plainly a distortion of the truth and does not add up with dates in more reliable sources.

[174]Meyer p.141.

Chapter Nine (1849-1862)
Broseley and Hendon

Thomas Mortimer's health continued to be poor. He was still under considerable strain relating to the Grays Inn Lane Chapel and had suffered a prolonged bout of painful and debilitating erysipelas[175] in the shins as far back as 1843. Despite holidaying in Dorking, Brighton and the Isle of Wight with Favell and Lethbridge on his doctor's orders, he continued exhausted by the worry and difficulty of the situation. He now wished to get rid of his responsibility to the chapel by retiring from it altogether. Edward (later Canon) Garbett (1817-1887), friend and supporter of J. C. (later Bishop) Ryle (1816-1900), joined Mr Mortimer at the chapel to help him. He was willing to take over the chapel when the legal difficulties had been sorted out. This took longer than expected and by the time the Mortimers finally managed to retire to Weymouth, Thomas was very ill. "His nerves were shaken and the burden of the chapel had been too much for him."[176]

Even then the saga of the chapel was not quite over. The ecclesiastical authorities constituted it a District Church and Lord Calthorpe, on whose estate the chapel was built, remitted the £120 ground rent. Mr Garbett became the minister and the Mortimers were relieved of any further responsibility – on payment of £500.

At this release, Mr Mortimer's health improved only slightly. The Mortimers attended Rev Charles Bridges' ministry at Trinity Church. It must have been pleasant for Favell to renew acquaintance with this saintly minister whom she had first met all those years ago when staying at Carlton Rode with her uncle.[177] Mr Mortimer was well enough to preach at Trinity himself from

time to time but he continued "feeble."[178] Then came the final stroke. "At midnight on July 29th [1850] he had an apoplectic fit, for which he was bled, leeched and blistered[179] and had his head shaved."[180] His doctor, along with these barbarous sounding treatments, forbade him to preach for a year – which for a man of Mortimer's stamp was probably worse than the bleeding, leeching etc. It must have seemed like a death sentence and, as soon as his condition would allow, he set off for Broseley in Shropshire. Why he was so anxious to go to Broseley is not quite clear. As a young man he had stayed with his half-brother George Mortimer, curate of Madeley, about four miles from Broseley, in order to train for the Church of England ministry. The two men remained quite close and continued to correspond when George became a rector in Canada until George's death in 1844. Mrs Meyer says Broseley was chosen because it, "seemed likely to suit them as a place of residence, and was near to the Madeley of his early recollections."[181] Thomas Mortimer had preached his very first sermon in Madeley from the pulpit earlier used by George Mortimer's hero, John William Fletcher (1729-1785), Wesley's friend and supporter. He had happy memories of Madeley. Why he, therefore, fixed on the nearby iron working town of Broseley and not on Madeley itself is a mystery.

Rev Richard Wilton (1784-1857), who was to know Favell well,[182] wrote that Mr Mortimer, "just came to Broseley to die,"[183] but this does not necessarily imply that he went there with the *intention* of dying as at least one later writer took it to mean.[184] Mr Mortimer got no further than Burton-on-Trent where he sustained another apoplectic fit while staying at the Three Queens' Hotel. Favell and Lethbridge hurried to join him as soon as they heard from the doctor who had treated him (bleeding again) and together they travelled on to Broseley, Mr Mortimer being somewhat better. Here they settled, presumably at Broseley Hall where Favell lived afterwards, but he continued to deteriorate and died a few weeks later.

Whatever stresses and strains Favell endured with Thomas Mortimer, she seems to have become more contented in her marriage towards the end of it. Certainly *after* Thomas Mortimer had died she decided that their marriage had been happy.

She sought comfort in her grief by visiting her brother Barclay (significantly perhaps, not RCL) and received a very kind letter of condolence from Henry Manning. Her niece explained Favell's attitude at this period:

> ...she thought of the companion she had lost, in whom the Word of God dwelt so constantly, the friend who prayed for her continually, and the minister who had been blest to so many. She recollected especially the last time he pronounced her name, looking in her face as he slowly uttered it, "Favell," and never speaking again...[185]

Despite her grief, exaggerated or not, Favell would probably have been happy at Broseley Hall for the rest of her days. She found a circle of friends there who exactly suited her tastes. The rector, the Honourable Orlando Weld-Forester (1813-1894), his wife and his little son Cecil (1842-1917) quickly became friends as did the tutor they had engaged for Cecil, Richard Wilton. Wilton was something of an ornithologist and Favell was fascinated, getting him to give her lessons in the recognition of bird song. Wilton was a little over-awed with Favell when he arrived in Broseley. After his first visit to Broseley Hall to take tea with Mrs Mortimer, he wrote, "Mrs Mortimer makes five hundred a year by her writing and she is now engaged on three or four works. Mr Mortimer just came to Broseley to die and there is still a kind of gloom resting over the house. Mrs M. is a tall, thin, pale, stately lady. She seems to aim too much at effect in her conversation and quotes poetry over the table rather rhetorically. You cannot forget that she is a learned lady. There is no doubt that she is a clever woman."[186]

Perhaps Favell was nervous at this first meeting and over reacted. At any rate, it did not take long before she and Richard Wilton were getting on well. He took to Lethbridge at once, "a fine-looking, gentle and gentlemanly man of devoted piety,"[187] and soon got to know Favell better. "I fear I have spoken too harshly of Mrs Mortimer," he wrote and then later, "we begin to square to one another and rub down the unaccommodating angles much much better than I could have supposed."[188]

This description at once strikes a chord. Years back, in the days when she was trying to convince Manning, Favell had written, "I enjoy rational conversation so much, that I regret the little time that pleasure can last,"[189] and "I like to stop and moralise at every step, to review, compare, conclude, and establish principles as I go on."[190] She even admitted later, "Friends of high intellect and charming manners are too delightful for me because they absorb my thoughts and engross my interest."[191] Wilton and Favell had long conversational walks together in the Foresters' park, discussing literature and religion and from Richard's remarks one can imagine some lively debate. Whether through Favell's influence alone or that of the Foresters, he dated his conversion from this period of his life. "I feel as though a veil had been lifted from my eyes and I have seen an excellency in the Gospel and beauty in Christ Jesus..."[192] he wrote from Broseley to his brother. Favell also gave him lessons in voice production, for which he was grateful. By getting him to read to her from behind a closed door she trained him to speak clearly without dropping his voice at the end of his sentences.

Orland Forester had two curates, both, "intelligent agreeable men," according to Wilton.[193] One of them, David McAnally (d.1919), had been converted under Thomas Mortimer's preaching. Favell appreciated McAnally's ministry greatly and appointed him tutor to Lethbridge. Should Lethbridge imitate Thomas Mortimer and train for the ministry without going up to the university? Rev John Bartlett, (d.1861) of Madeley (probably an old friend of Mortimer's) advised him not to follow his late mentor's example and Favell and Lethbridge took the advice. Accordingly, he was now preparing for Cambridge. Lethbridge's mother and his sister Minnie joined him at Broseley Hall and it seems to have been a very happy household despite Wilton's initial remark about "gloom." Favell loved the tame sheep and lambs that grazed on the lawn by the church outside the house. Minnie looked after the poultry (this was considered a suitable amusement for young ladies at the time) and Favell received visits from family and friends as well herself visiting as far as Lytham St Annes and Liverpool. Her household staff included two widows named Pugh and Smith and a girl from Mrs Kinnaird's Servants' School[194] called Poppy.

In due time, Lethbridge went up to Cambridge. He returned to Broseley in the vacation and continued his studies while at home. This time Richard Wilton was appointed by Favell to supervise his vacation education. Wilton was free to do this as little Cecil (after plaguing his poor tutor nearly to death) had been sent off to school. With Lethbridge, Favell went up to Cambridge, visiting the colleges and taking tea at his college – Caius.

And all the while Favell was working harder than ever at her writing. Her main occupation during her time at Broseley seems to have been her geography books. Being Favell, she was not content with the current methods of teaching geography – methods satirized by Lewis Carrol in *Alice in Wonderland* where poor Alice is reduced to garbling, "London is the capital of Paris, and Paris is the capital of Rome, and Rome—no, that's all wrong, I'm certain!" Favell was concerned that children should be interested in the world and its peoples and understand it from a biblical point of view. Accordingly, she set about combing through a vast mass of missionary magazines and similar publications to find stories and information which could be classified into geographical areas and retold for children. Her mind must have gone back to the well-travelled Christians she had met at Carlton Rode all those years ago before her marriage and the enthralling stories they had to tell.[195] Any modern Christian teacher who has tackled early geography by means of books such as Operation World's *Pray for the World*[196] will have experienced the value of this approach. At once Christ is at the heart of the subject and the child's interest is aroused.

Favell also realised that for very young children stimulating an interest in Geography was far more important than getting them to remember specific facts. "Superficial, incomplete, trifling! Such is the true character of this book," she began the preface to the first book *Near Home*, ably demonstrating her own advice to RCL about opening sentences.[197] As an explanation she added that this was, "...because it is intended for a race of beings [small children] whose taste must be consulted." She continued, "when once the desire [to learn] is excited the chief difficulty of the teacher has vanished and now the child will learn more *without* a teacher, than

before with one." She concluded by explaining her motives, surely those of any Christian teaching Geography to little ones, "In this little book the attempt is made at every turning... to show that the world which God MADE ought to be governed by the book which he WROTE."

The passage of time has rendered the contents of both *Near Home* and *Far Off* out of date. The principles on which they are based, however, remain sound and a better method for beginning geography with little ones is hard to imagine.

All Favell's books cost her an immense amount of labour. The books in the *Peep of Day* series had a long gestation and the material in them was honed to perfection during Favell's classes in Belmont, Fosbury and probably even the little school in the laundry at Hale End. The geography books were different: they were the product of a more concentrated effort. Favell made sure, however, that they were thoroughly tested. According to Richard Wilton, she was in the habit of reading all her work to a child to see how it was received and she always adapted what she had written in the light of this unique consumer research. While at Broseley, she made use of little Cecil who had driven poor Mr Wilton almost mad with his pranks. Cecil thought nothing of locking himself into the schoolroom and refusing to open the door and he regularly enlivened their daily walks by pushing his poor tutor into the ditch. Yet it was Cecil whom Favell selected as her "censor." He would have been a most exacting critic, easily bored and perfectly able to show it. For an hour every day at Broseley, Favell read her manuscript to Cecil, ruthlessly removing anything he did not enjoy. A book that passed the strenuous test of interesting this intolerable, wilful, disobedient and petulant child[198] would certainly delight and fascinate less spoilt children.

While Favell was adapting to life as a widow in Broseley, far away in Devon the Rev George Cornelius Gorham (1789-1857) was finally instituted as vicar of Brampford Speake. It was probably the most significant institution in the entire century. Favell, like everybody else in England, would probably never have heard of him but for the fact that the bishop of Exeter had previously

refused to institute him. Henry Phillpotts was a pugnacious bishop whose intractable character still confronts us in the huge brow, granite features and clenched jaw of his photograph.[199] He was determined that no new vicars would be instituted in *his* diocese who did not subscribe to the view that being baptised made a baby regenerate. This Gorham would not do. He took his case to the highest court he could, the Judicial Committee of the Privy Council, and won his case. There was a huge amount of publicity. Evangelicals breathed a sigh of relief. Now, no high church bishop could prevent an evangelical curate being ordained just because he *was* an evangelical. No doubt Lethbridge Moore also had been following the case anxiously. A different decision might have closed to him the Church of England ministry, for which he was training.

The Gorham judgment had different repercussions elsewhere. The relationship between Evangelicals (and especially their children) in the Church of England and those who were heading in the direction of Rome was a curious one. William Wilberforce's children were not the only sons of Evangelicals to move to Tractarianism and then to Rome itself. Many other Evangelicals – the Newmans, the Ryders, the Sargents, not to mention Gladstone's mother as well as the Mannings – had children who became either High Church Tractarians or crossed over altogether to Rome. Archdeacon Henry Manning, looking for his three signs from God, had received, as he thought, the first when Renn Dickson Hampden (1793-1868), promoter of the campaign for the admission of dissenters to Oxford and Cambridge Universities, was made a bishop in 1847. The Gorham judgment was the second sign. Baptismal regeneration is a Roman Catholic teaching. It was Manning's view that the Church of England should embrace this teaching more strongly rather than deny it. The Gorham judgment brought Manning another step nearer to abandoning the church of his own father, and of Favell.

Manning's third sign came inevitably. In September 1850, the Pope unilaterally restored the Catholic hierarchy in England, setting up a system of diocese and bishops in opposition to that of the Church of England and appointing a cardinal. A storm of

protest broke especially in London. Favell's hero, Dean Hugh M'Neile, addressed meetings, and the Guy Fawkes' Night bonfires provided a focus for the expression of outrage that such a thing could be allowed. The following year Parliament passed the Ecclesiastical Titles Act 1851 which outlawed the use of episcopal titles[200] by anyone outside the Church of England although the law was never enforced and was repealed in 1871.

Manning heeded his three perceived signs. He resigned as Archdeacon of Chichester and after a period of hesitation he was received into the Roman Catholic fold by the new Cardinal Wiseman, beginning at once to study for the Catholic priesthood. His action was greeted with a storm of criticism, elation, anger and triumph. Manning was at last on his way to the political power and influence he had always sought. In due time, he himself would become His Eminence Cardinal Manning, Archbishop of Westminster.

Did Favell ever suspect that Manning would take such a step? All that her niece says of this matter is that the news caused her "grief."[201] To the end of his days, Manning described Favell as his "spiritual mother" which is a significant title. Other evangelical mothers had lost their sons to Rome. Favell lost this "spiritual son" and she probably felt the loss deeply. Certainly when she considered the time spent on Manning, she "felt how much better [it would have been if] it had been spent over the poor orphan Louisa Aschel."[202] Louisa's letters from Australia overflowed with gratitude to her adopted mother for her spiritual help which had led to her conversion later in life. It was a sad contrast.

Favell was quietly happy in Broseley, very fond of the Foresters, and also of the servants at Broseley Hall. She had taken a "poor invalid woman"[203] named Mary Oakes under her wing also, with whom she did not want to part. However, in 1855 she moved from Broseley to Eldon House in Hendon taking Mary Oakes and some of the servants with her. This was because David MacAnally, the curate whose preaching at Broseley Favell so much enjoyed, had obtained an appointment as curate to the Hon John Pelham (1811-1894) Vicar of Christ Church, Hampstead. Hendon was within

reach of Hampstead and Favell wished to continue to benefit from MacAnally's ministry, although she was concerned that she might be making a wrong move.

There were some advantages to Hendon. She was now much nearer her relations and some of her old friends. She was about seven miles from her sister Louisa at Osidge and her brother RCL at Trent Park. Now she could enjoy outings to the *fêtes* for Shaftebury's shoeblacks, and the school children from Mrs Kinnaird's and Mr Pennefather's schools which were a feature of life at Trent Park.

When Lethbridge finished at Cambridge in 1857, Favell went up to see him take his degree and he then joined her at Eldon House. That same year the last of Favell's maternal uncles Richard Lee died at the age of 92. He had been a very rich man. He had survived the near wreck of the family fortunes at his father's death as well as the tragic suicides of all his other brothers and was something of a miser despite his riches. Favell was astonished to find that she had been left a very large sum of money indeed.[204] Uncle Richard was not a believer and as a consequence any pleasure Favell might have felt at receiving the legacy was in her words, "a black sort of joy."[205] She was now, however, quite a wealthy woman.

It was not long before it was realised that moving to Hendon may well have been a mistake. The Hon John Pelham was appointed Bishop of Norwich and so his curate Mr MacAnally had to move too. Since his move to Hampstead was the reason for Favell's leaving Broseley, she was somewhat disappointed. However, Pelham was succeeded by the young Edward Henry Bickersteth (1825-1906), son of the noted hymn-writer. Here again was another evangelical minister who quickly became a good friend.[206]

Always an enthusiastic traveller, Favell set off with Lethbridge and his sister after his ordination to to visit York, Berwick, Abbotsford (the baronial hall of Sir Walter Scott and by this time a tourist attraction), Edinburgh, Perth, St Andrews and Sheffield.

On their return, Lethbridge became Mr Bickersteth's curate and also preached at Christ Church, Trent Park. Here he met his future wife, Miss Agnes Emma Shuttleworth, sister of R C L Bevan's second wife. He and Agnes Emma were married in 1859. When their first baby, Mortimer Ughtred, (known always as Merty) was born, Favell was overjoyed. She doted on this "grandson" and spent her time with him constantly, eulogising over his delightful temperament and beautiful appearance.

Throughout this period she was working on a Greek Primer. No trace of this book remains except in her niece's[207] biography, so she may have abandoned it. Perhaps she felt it was not up to her usual standards. It is possible that she learnt the basics of New Testament Greek along with Lethbridge in the days when he was preparing for Cambridge. Certainly it is unlikely that she learned any Greek as a child herself, as girls at this period rarely learnt Latin let alone Greek and Favell herself seems to have learned Latin very late in life.[208]

A Mr Summers brought Favell his three little orphaned nephews while she was living at Hendon. She looked after them and educated them, possibly with the help of Mary Oakes who later acted as a kind of "Matron" for the various orphans with whom Favell surrounded herself after Thomas Mortimer's death.

Meanwhile Lethbridge was offered a living. John Pelham, now Bishop of Norwich, offered him Sheringham, twenty-five miles from Norwich and not yet on the railway. Favell must have quailed, keen traveller as she was, to think of Lethbridge and his family – especially Merty – being so far away. There was nothing for it – she would have to move too. This time the move was definitely not a mistake.

Endnotes

[175]A cellular infection which was difficult to treat in the days before antibiotics.

[176]Meyer p.141.

[177]See Chapter 3.

[178]Meyer p.143.

[179]Blistering was used to treat a wide variety of maladies. It was believed that the body could only hold one illness at a time, and that therefore blistering the skin with hot pokers, acid, or plasters could, as it were, burn out another illness.

[180]Meyer p. 143.

[181]Meyer p. 143.

[182]See below.

[183]Letter by Richard Wilton quoted in Wilton p.99.

[184]West, Veronica, "Broseley Hall and Thomas Farnolls Pritchard," *Broseley Society Journal* no. 10, 1982.

[185]Meyer p.149.

[186]Wilton p. 99.

[187]Wilton p.100.

[188]Wilton p.100.

[189]Meyer p. 36.

[190]Meyer p. 36.

[191]Meyer p. 138.

[192]Wilton p.101.

[193]Wilton p.95.

[194]See Chapter 8.

[195]See Chapter 3.

[196]This book gives information about each country including the number of Christians, whether they face persecution and what their problems are etc. in order that the reader can pray for them.

[197]See Chapter 8.

[198]Wilton p.110.

[199]Reproduced facing p.371 of Newsome, David, *The Parting of Friends,* (London, 1966).

[200]Such as "bishop", "dean" etc.

[201]Meyer p.148.

[202]Meyer p.181.

[203]Meyer p.160.

[204]Uncle Richard Lee left the immense sum of £600,000 at his death – not all of it to Favell, of course. Calculated in terms of GDP the modern (2016) value is in the region of £75 million.

[205]Meyer p.164.

[206]Meyer p.161. Bickersteth's claim to fame is his collection and editing of his father's hymns, some of which are still in use including the missionary hymn, "For My sake and the Gospel's, go and tell redemption's story".

[207]Meyer p.172.

[208]See Chapter 10.

Chapter Ten (1862-1878)
West Runton

Nothing of The Rivulet, Favell's house at West Runton, remains and the little stream that gave the house its name has long since been consigned to a culvert. Runton House, the rather grand property that Lethbridge built on the site of The Rivulet after Favell's death is still standing, however, large and imposing with tall chimneys and a grand front door. Favell's house was a totally different kind of dwelling. One of her nieces, who stayed there regularly as a child after Favell's death, described it as a "lovely cottage... thickly overgrown with honeysuckle and roses."[209] Inside was a square central hall "into which the drawing-room, library and door leading to the kitchen all opened."[210] This hall Favell adorned with a larger than life bust of her late husband and Edwyn Bevan recalled seeing the "fat features and the dreadful smirk above the Geneva bands"[211] of this hideous likeness when he visited The Rivulet as a small child. The entrance was by means of a little porch overhung with clematis.[212] When Favell moved there in 1862 it was, "a frail building"[213] "embowered in trees,"[214] which had belonged to the neighbouring rector of Beeston. Favell, considered that, frail or not, it would last her out now that she had "entered her seventh decade,"[215] and so she rented the house.

But Favell was anything but finished yet: she had plenty of energy. The Pughs came with her as servants, also Mary Oakes and the orphans for whom Favell was caring and whose number had now risen to six. Mary Oakes had charge of these children and lived with them in a small cottage opposite The Rivulet. How an invalid could have looked after six children is puzzling, but

without knowing anything of the nature of Mary Oakes' disability or even her age it is useless to speculate. The 1871 Census data for West Runton lists a "Matron of an orphan asylum"[216] – perhaps that was Mary Oakes. Favell certainly spent plenty of time with the children herself, taking them out "a great deal to enjoy themselves among the furze."[217] There was soon a pet lamb to be reared by hand by the little ones and Favell had some steps or stairs cut into the cliff so that the beach could be easily reached. "I visit the beach after breakfast with a train of children," she wrote in the May of her first year in West Runton, "the baby[218] [is] carried by four in a plaid down the stairs... He is so happy among the stones and sands that it is hard to get him up again..."[219]

The scenery pleased Favell immensely. West Runton was not a tourist resort as it is now, there being no railway as yet. The cliff top walk through cornfields, the stream that passed through the garden of the house, and, of course, the sea itself all delighted her. She took the children hay-making, sitting with Merty and the orphans in a "hay-nest" and then working at hay-making "till our bones ached."[220] She had her pony and a donkey chaise and, still an expert horsewoman, these enabled her to get about. At first, Lethbridge and his family (including his mother) lived with her at The Rivulet because there was nowhere available at Sheringham. Favell revelled in being surrounded by so many young people.

Old family friends and distant relations of the Bevan family, the Buxtons, the Barclays, Gurneys and others lived nearby and Favell was fascinated by a visit to the family home of the Buxtons at Northrepps where parrots and cockatoos nested and bred in trees in the grounds. Favell herself acquired a parrot when she lived at The Rivulet and one wonders if it was a gift from the Buxton collection.

Fast-changing weather conditions were a feature of the North Sea coast as fishermen from nearby Cromer and Sheringham knew to their cost. A glorious early fine morning could see the fishing fleet set out only to be met later by a severe storm. The violent gales that swept in on 25th October 1869 were typical. George Jenkinson (1816-1876) of the *Good Intent*, a Primitive Methodist

preacher who was out with the fishing fleet from Filey, way to the north of West Runton, explained, "On Tuesday, the waves were of mountainous size, and very threatening. We prayed for help; and the Lord heard us... On Wednesday when we saw several of the boats breaking away from their warps,[221] our hearts were ready to fail us; but the Lord was greater than our hearts... Prayer was answered; towards evening there was a comparative calm..."[222]

West Runton too suffered from the storm, but the vessel that was wrecked on the beach near The Rivulet was not a local fishing boat. The next day, the billy-boy[223] *Trinity*[224] lay below the cliffs battered but in one piece with her cargo of grain bound for Newcastle scattered over the sands. The crew of three, Captain Cornelius Emerston, his mate and boy, were safe at Sheringham, having been taken off by the Lifeboat *Duncan*. The grain was far from useless. It was no longer fit to be milled into flour, but the salt water killed the spores of the dangerous smut fungus which could destroy a wheat crop. The wheat was auctioned and local farmers bid for it knowing that it would yield a good harvest.

Like the *Trinity's* cargo, Favell's orphans might be storm-tossed but they had been washed ashore somewhere where they were wanted. Their numbers rose steadily. Little two year old Nancy, the orphan of a sergeant joined them, "a pleasant surprise to us all,"[225] wrote Favell, glad as ever to have little ones around her. Her educational principles mellowed as she grew older and she wrote to her old friend Miss Maria Dennis:[226]

All zealous young teachers fall into the error of giving too early and too much instruction. I almost tremble when I think my little sister [Francis, taught by Favell herself] could nearly read and knew many little verses at Merty's age, [four] while he knows nothing but his letters, which he picked up, and not one line of poetry, but spends his joyous infancy in playing and seeing pictures. You have seen the slight importance of all but heavenly knowledge, and you have tasted the earnest of the blessedness flowing to those who have imparted it, though to know its fullness is reserved for the future meeting.[227]

However, it is difficult to calculate how far this new attitude to early education was caused by mature reflection, and how far by her tendency to spoil Merty! Certainly, he did not prove a good long term advertisement for this change of principle. When Merty grew up, he rejected everything Favell stood for and took up Theosophy,[228] going to India with Mrs Annie Besant (1847-1933) the Theosophy teacher and advocate of Indian independence. He returned "many years later" bitterly disappointed,[229] but there is no record of his ever having been converted.

While at West Runton, Favell continued her writing. She completely revised *Reading Without Tears* adding new material, much of it from her recent experience. She even included an exciting episode where her poor donkey nearly drowned!

This near disaster happened when Favell drove down to the beach one morning with the donkey chaise. The younger children were in the chaise and the older ones running alongside. On the way, they encountered the postman and took the post from him, putting it into the chaise. Favell wanted the donkey to bathe its legs in the sea water as the salt water was well known to be good for the legs of horses – and so presumably those of donkeys as well. The donkey seemed afraid when it saw the water so Favell blindfolded it with her shawl. Blindfolding horses was, and still is, often practised. They can be trained to go blindfold so that in case of danger (typically a stable fire) a blindfold can be applied and a horse that would otherwise panic at the sight of flames or other danger can be led to safety. Unfortunately Favell did not unhitch the donkey from the cart. She told the bigger girls to lead the donkey into the water which they did. A larger than usual wave, however, made them drop the rein. The donkey was afraid and being blindfold and having the cart behind he began to run deeper and deeper into the water.

The poor animal would certainly have drowned but for the prompt action of some local fishermen who, hearing the cries of distress from the children, rowed quickly over and pulled the drowning creature out of the water by his jaws, grabbed the bridle and dragged him ashore. Somewhat surprised to find the

shivering donkey had been blindfolded they were nevertheless glad to be rewarded for prompt action. As for the letters, they were "lost at sea" and never seen again.

When Lethbridge and his family moved into the new rectory at Sheringham, Favell decided to remain with her beloved orphans at The Rivulet and accordingly she purchased it outright. Her family continued to grow.

Edward Leathes Wilson (1862-1900), great-grandson of the evangelical Bishop Daniel Wilson[230] of Calcutta (1778-1858), an associate of Wilberforce, was brought to Favell by his parents. Aged nearly seven, he lived with her, sharing lessons with the orphans and with Merty who also came to stay at least from time to time. Another child arrived, the son of a "Mr Starey" from Lambeth. Nicknamed Mertino, he was Edward Wilson's fellow-student and companion. Favell began to teach herself Latin from Thomas Kerchever Arnold's popular textbook *Latin Prose Composition* (1839) with the evident aim of teaching Latin to the boys. This was to bear fruit in her *Latin Without Tears* published right at the end of her life. The children occupied her most of the day. She took great pains with their reading.

> With my boys I am most particular about reading, insisting on the right pauses. It is surprising how soon the art of making them can be acquired, as well as the habit of speaking out the last word.[231] Good reading is an acquisition that renders a boy's knowledge profitable and interesting to others. With Edward [Leathes Wilson] I hope the third time will do what the second failed to accomplish. But who shall overcome the tendency to jumble? He is not deficient in power, but in reflecting and seeing the point. Yet he may prove a blessing, for the race is not to the swift. It is amazing to see the boys' enthusiasm about their Latin. Starey has counted 350 words he knows, all classified grammatically. He is charmed to learn anything new.[232]

Edward seems to have found his lessons difficult. Favell described him as "marble to receive and sand to retain."[233] Perhaps

his "tendency to jumble" indicates he was dyslexic. Certainly he had had a difficult start in life. A younger son of a family of whom much was expected, rather like the young Wilberforces, he was overshadowed by older siblings, cousins and uncles.

In the evening she continued her writing. In fact, she often made herself unwell because she insisted on resisting any feelings of weariness and sitting up until one in the morning working. "Proofs, letters, teaching, guests, filled up the day..."[234] she was busy as ever.

By 1873, however, when Favell was seventy-one, she had become weak and had possibly suffered a slight stroke. The boys were sent to continue their education elsewhere, but the orphans remained and as they went off into service or trades others took their place. A Jewish boy, Freddie Alexander, arrived and another little boy, William Woodward. Favell taught them but was only able to do so because they were "extremely good." She seems to have engaged a governess to help her with their education, but learning Latin was such a trial to them that lessons with the governess reduced them to tears. Despite being quite ill, Favell perfected her book *Latin Without Tears* which made Latin more palatable by its method of "one word a day." She was rewarded by a transformation in their attitude to Latin. In the preface to the book she explained:

> ...it is not I who have written this book, but two little boys, Freddie and Willie, under the care of a governess. I was so sorry to see little boys often crying over their Latin lessons, and I thought of this plan of telling them a word a-day, and I told the little boys to make sentences with them. At breakfast there were shouts of joy on hearing the new word, and there were leaps as well as shouts when running into the drawing-room after breakfast to show me their new sentences upon their slates. After one year and a half these boys, between seven and nine years old, could read the Latin extracts from St. John at the end of this book.

Edwyn Bevan[235] says that by this time Favell was becoming definitely eccentric. He cites, for example, her killing her parrot by bathing it in soap and water and insisting it rested lying on its back. He also relates the family tradition that she buried her pet lamb in the sand to dry it off after making it bathe in the sea. Edwyn also claims that she was less than even-handed in her treatment of the orphans and had definite favourites. Requiring very little food herself, she expected growing children to do the same and he hints that the orphans must often have been hungry. His reliability as a source has already been discussed, but it has to be admitted that there must have been something behind the family traditions that he relates. What is clear, however, is that these quirks of her closing years are not in any way linked to her books, her life's work or even her over-all personality. The onset of dementia (which is what he seems to be describing) should not taint the whole picture. Favell had not been like this all her life. Edwyn's remarks have been used over the years by those far less in sympathy with Favell's aims even than he, to condemn the books themselves as the products of an overbearing and cruel old lady.[236]

Further slight strokes deprived Favell of speech and mobility and Freddie and Willie had to leave her in 1876. Letters of gratitude still arrived to cheer her, from as far away as Australia where not only the very first of her orphans, Louisa Aschel, but now the eldest of the Runton girls, Susan, had settled. Susan, nearly shipwrecked *en route* and then lonely and over-worked, was homesick for The Rivulet. She kept up her correspondence with her benefactress and things got better. She married and named her first child "Alfred Mortimer." Like the valuable sea-washed wheat, the orphans were beginning to produce a harvest in an unexpected place. Letters came from young Edward Leathes Wilson and another correspondent wrote, "One of my most precious possessions is a well-worn copy of *Peep of Day*, the early delight and study of two nephews who perished at Cawnpore[237], aged nineteen and twenty-one."[238]

Favell struggled on now deaf and at times almost unable to speak but still working compiling a list of questions for a new

edition of her book, *Kings of Israel and Judah* in the *Peep of Day* series. Lethbridge, completely devoted to her, did everything possible to help and in the winter she moved into the rectory at Sheringham. She went back to The Rivulet when the weather got warmer and was able to go about in her donkey carriage. Gradually, she grew weaker, reduced to trying to communicate at last with friends and family who came to see her by means of a slate. One of her last visits was from Maria Dennis who had been her friend since the far off days at Hale End and Marsh Street Chapel. This dear old spinster remained at the Rivulet, keeping Favell company to the very end.

Favell was looking forward to heaven. She expressed a hope that she would not outlive "the dear Dean" Hugh M'Neile and she did not. Long before, she had told "her" boys that when they heard that she had gone to her heavenly home they were to "pick the brightest flower in the garden and wear it for joy."[239] She died a gentle death surrounded by her family and friends having fallen asleep in the arms of her niece[240] on August 22nd 1878.

Favell's funeral was held at Lethbridge's church in Sheringham. The burial service was read by her great friends Canon Forester and Mr MacAnally. Richard Wilton, whose poetic gifts she had so much admired, wrote her epitaph. Her brother (Barclay one assumes) was there and so was her niece (Mrs Meyer probably) and the orphans with their Matron (Mary Oakes?) laid a wreath of flowers from her own Rivulet garden on her grave. Happy Favell, with her beloved Saviour at last in that kingdom where "the Peep of Day is exchanged for Meridian Light, the Far-off becomes the Near, and we need no longer Line upon Line, or Precept upon Precept, because that which is perfect shall have come and that which is in part shall have been done away."[241]

Endnotes

[209]Webster. p.86.

[210]Webster. p.88.

[211]Bevan, Edwyn, "Peep of Day: A Lawgiver in the Nursery" *The Times*, June 27th 1933.

[212]Meyer p.206.

[213]Meyer p.175.

[214]Meyer p.177.

[215]Meyer p.175.

[216]http://www.runtoneastandwest.co.uk/history.htm accessed 27/05/16.

[217]Meyer p.176.

[218]Probably Merty who was often with her.

[219]Meyer p.177.

[220]Meyer p.177.

[221]The warps were the ropes that held the nets to the boat.

[222]Quoted in Kendall, Charles, *God's Hand in the Storm*, (1870).

[223]This type of vessel was a coastal schooner with a box-like shape to hold a large cargo.

[224]Some accounts give the name as *The Trusty.*

[225]Meyer p.181.

[226]Daughter of the art expert: see Chapter 1.

[227]Meyer pp.181-182.

[228]Theosophy is an occult movement which claims to have access to secret divine wisdom.

[229]Webster p.88.

[230]Wilson had been sent to Calcutta by Charles Simeon.

[231]Did they, like Richard Wilton, have to practise from behind a door one wonders?

[232]Meyer pp.192-3.

[233]Meyer p.195.

[234]Meyer p.193.

[235]Bevan, Edwyn, "Peep of Day: A Lawgiver in the Nursery" *The Times,* June 27th 1933.

[236]See for instance, Pruzan, Todd, *The Clumsiest People in Europe,* (New York, 2005).

[237]The siege and horrific massacre in 1857 at Cawnpore (now Kanpur) took place during the India Mutiny.

[238]Meyer p.198.

[239]Meyer p.208.

[240]Almost certainly the niece who wrote her biography, Mrs F. B. Meyer.

[241]F. B. Meyer in Preface to Meyer p.*vii*.

Chapter Eleven
Evaluation

There is no doubt that Favell had a happy knack of writing for small children. It was a knack acquired through diligent practice and experiment and it consisted of choosing vocabulary with care, using questions to stimulate a response, selecting material that would catch the attention, being blunt and straight-forward and – most important – knowing when to stop. These are methods which are still valid when teaching little ones and she used them skilfully. Even her most vicious critic acknowledged her writing style was engaging, calling it "direct, persuasive, forceful."[242] All this would have been of little value, however, if the subject matter with which Favell was dealing was not of supreme importance. It was her careful union of superb writing for the task in hand and vitally important subject matter that made her work outstanding. Robert Hall,[243] an author Favell enjoyed reading from her youth, explained the importance of the subject clearly in a sermon on Proverbs 19 v. 2 arguing forcibly for the education of the poor and for their religious education in particular:

> Religion, on account of its intimate relation to a future state, is every man's proper business, and should be his chief care. The primary truths of religion are of such daily use and necessity, that they form, not the materials of mental luxury, so properly as the food of the mind. Two considerations may suffice to evince the indispensable necessity of Scriptural knowledge.

> 1. The Scriptures contain an authentic discovery of the way of salvation.

2. Scriptural knowledge is of inestimable value on account of its supplying an infallible rule of life. Of an accountable creature, duty is the concern of every moment, since he is every moment pleasing or displeasing God. Hence the indispensable necessity, to every description of persons, of sound religious instruction, and of an intimate acquaintance with the Scriptures as its genuine source.

Favell was, no doubt, a child of her time. In the 1830s, a new wave of revival had swept the country, leaving almost every town or village with some evangelical witness. This up-lifted the general morals of society to such an extent that behaviour such as that indulged in by Favell's maternal uncles was not even discussed – much less practised openly. A tremendous desire arose to reach the poor and especially children with the gospel. An army of teachers, district visitors, city missionaries came forward to meet the need. Favell's books – her life work – sprang directly out of that teaching and visiting. But another generation arose; how would it view the drab little books with their stern message? A small clue to the place her books still held can be found in the later history of her publisher.

Hatchards of Piccadilly is still one of the most famous bookshops in the world, although no longer a publishing house. It has had an interesting history and one of its most distinguished and successful partners was A. L. Humphries (1881-1924). When Humphries first arrived in London in the 1890s, he was still just a humble errand-boy with the Bristol bookseller, William Mack. In his free time, he was fond of exploring the city. Mack had recently moved his premises to London's Paternoster Row and Humphries spent his Saturday afternoons off examining its many bookshops. One afternoon he strayed as far as Piccadilly and found himself opposite Hatchard's. He was unaware then, that one day he would be a partner in the grand firm at whose premises he was now gazing. Already an astute book salesman despite his lowly post, he at once recognised the shop with its impressive black and gold pillars as the publisher of the single best-selling children's book of his day. "Why!" he said to himself, deeply impressed, "that is where they publish *The Peep of Day*."[244]

When the little book reached its 100th anniversary, Favell's nephew Edwyn Bevan wrote in *The Times* that it had "still a considerable circulation"[245] and this continued to be the case for many years. *The Peep of Day* (in both its original[246] and an updated[247] form) and *Line Upon Line* are still in print and as far as I can tell have never been out of print.

That Favell's books were so popular for such a long period was unusual. They were not flashy best-sellers – here today and gone tomorrow – but enduring books and books with a vital message to get across. That they sold so widely for so long is an indication that the revival of the 1830s had not completely faded away. There was at least some feeling in society at large that children should have basic religious instruction. That this need should have been met by Favell's books with their clear message of sin, death, judgment, hell, repentance, salvation, mercy and heaven all spelled out in nursery-sized portions was nothing short of a national blessing.

The topic of reprints and editions of Favell's work would not be complete without a mention of the strange modern reprint of extracts from her geography books edited by an American journalist under the title *The Clumsiest People in Europe*.[248] With little or no understanding of why she wrote what she did or even of what other contemporary children's literature on the subject was like, he holds up quotations from her books as objects of laughter and derision. These are preceded by an introduction which describes Favell's books as a "vicious, systematic, country-by-country savaging of the entire world."[249] He explains that after finding one of her books in a second-hand book barn he and his friends "sat around in our backyard, drinking beer and passing the book around, hooting and slapping our wooden picnic table as we read aloud [from it]..."[250] His whole book is an example of exactly how not to treat any text from the past and no-one would get an accurate picture of Favell's work by reading it. I hope that the present book has provided a more measured and accurate assessment of her books and set her life and work in its proper context.

There is a peculiar problem in developing any method of education. It must necessarily be put into practice before its effectiveness has been properly evaluated. It is not possible to change or adapt the formula retrospectively once the children upon whom it has been used have grown up. In modern times, rapid changes in educational methods have taken place with the result that children are constantly exposed to untested systems for which there is no long-term evidence of success. Favell's books stand out in contrast to this sorry state of affairs – perhaps because the education they imparted was so often delivered by parents rather than school teachers! Parents used her books for well over a hundred years, which is plenty of time to consider whether or not they achieved their objective. This fact is in itself evidence that they passed the test with flying colours. The parents that purchased the little books in succeeding generations did so because as children they themselves had found in them the vital truths they needed. They were confident that Favell's books would teach their own children the same valuable lessons. Eternity alone will reveal how many saints began their journey to the celestial city by pondering:

> Who put the sun in the sky?
> Can you reach up so high?

Endnotes

[242]Pruzan, Todd, *The Clumsiest People in Europe,* (New York, 2005) p.3.

[243]See Chapter 4.

[244]Humphries personal notes quoted in James Laver, *Hatchards of Piccadilly 1797-1947,* (London, 1947)

[245]Bevan, Edwyn, "Peep of Day: A Lawgiver in the Nursery" *The Times* June 27th 1933

[246]Published by the Free Presbyterian Bookroom.

[247]Published by Christian Focus.

[248]Pruzan, Todd, *The Clumsiest People in Europe,* (New York, 2005).

[249]Pruzan, Todd, *The Clumsiest People in Europe,* (New York, 2005) p.3.

[250]Pruzan, Todd, *The Clumsiest People in Europe,* (New York, 2005) p.3.

Annotated Bibliography

Many letters of members of the Bevan family, probably including those of Mrs Mortimer herself and possibly even her journals, are still extant. They are not at present accessible to researchers. It is to be hoped that, with the passage of time, they will be deposited somewhere where they can be examined. Mrs Mortimer's nieces, Louisa Meyer and Helen Webster, and her great niece, Audrey Gamble, all had access to this material as had Anne Powers, also a descendant of the Bevan family. With the exception of Helen Webster who was writing primarily about her own life, not that of her aunt, they all transcribed large sections of this correspondence and Meyer and Webster clearly had seen not only Mrs Mortimer's journals but also the diaries of her mother, Mrs Favell Bourke Bevan. One would give much to see these diaries of which Webster wrote that they "...consisted mostly of pious reflections."[251] From what is known of Mrs Bevan, it can be conjectured that the modern Christian reader would benefit spiritually from their contents. These diaries would also give an insight into how an earnest believer of the pre-Victorian and early Victorian periods applied Scripture to daily life. For the present work, the secondary sources cited here have been relied upon. One day perhaps it will be possible for someone to use the primary sources for a PhD dissertation.

NB:- Abbreviations in square brackets are those used in the present book for frequently cited works.

Anon, *A family record, or Memoirs of the late rev. Basil Woodd ... and of several deceased members of his family* (London,1834)

Barrow, Isaac, *Theological Works* (Oxford,1830)

Bartlett, David W., *What I Saw in London* (New York, 1852)

Bebbington, D.W., *Evangelicalism in Modern Britain* (London, 1989)

Bevan, Edwyn, "Peep of Day: A Lawgiver in the Nursery" *The Times* June 27th 1933
Edwyn Bevan (1870-1943) was Mrs Mortimer's nephew. His article is the source of the suggestion that Thomas Mortimer treated his wife "cruelly." I can find no references to this that are not traceable to Edwyn's article. He was only eight when Mrs Mortimer died and never knew Thomas Mortimer.

Brown, Andrew, J., *The Word of God Among All Nations* (London, 1981)

Brown, Ford K, *Fathers of the Victorians* (Cambridge, 1961)

Budden, H. D. *The Story of Marsh Street Congregational Church Walthamstow* (Margate, 1923)

Carter, Grayson, *Anglican Evangelicals* (Oxford, 2001)

Cass, Frederick Charles, *East Barnet* (London, 1885)

Christian Guardian and Church of England Magazine Volume 4 1812

Eedes, John, *Scriptural Reproof, In A Letter to the Rev. Thomas Mortimer, B. D. Occasioned by his Unwarrantable Attack on the Ministerial Character of The Late Rev. William Huntington...* (London, 1837)

Gamble, Audrey Nona, *A History of the Bevan Family* (London, 1923) [Gamble]
Audrey Nona Gamble (neé Bevan) (1878-1944) was a great niece of Mrs Mortimer and was born in the year of her death. A meticulous researcher, she had access to many precious family documents which are not publicly available.

Harding, W., *The Church of England Preacher or Sermons by Eminent Divines*, (London, 1837)

Hobsbawm, E.J. and Rudé, George, *Captain Swing* (London, 1969)

Laver, James, *Hatchards of Piccadilly 1797-1947* (London, 1947)

Meyer, Louisa Clara, *The Author of the Peep of Day. Being the life story of Mrs. Mortimer* (London, 1901) [Meyer]
Louisa Clara Meyer (neé Bosanquet) (1826-1922) knew her aunt very well, shared her faith and probably helped her in her Belmont school as a teenager. She also knew her husband, Mr Mortimer. This makes her biography a very valuable source. Her sympathetic treatment of her aunt means that she may have left out any negative references. Writing before Gamble, she too had access to family documents including her aunt's journals.

M'Neile, Hugh Boyd, *The Adoption and other Sermons* (London, 1864)

MacNeile, Hugh Boyd, *The Church and the Churches; or, the Church of God in Christ and the Churches of Christ Militant Here on Earth* (London, 1847)

Munson, H. Lee, *The Mortimer Gun Makers* (Rhode Island, 1992)

Newsome, David, *The Parting of Friends* (London, 1966)

Pound, Pandora, Bury, Michael and Ebrahim, Shah, "From apoplexy to stroke" *Age and Ageing 1997*; 26: 331-337

Powers, Anne M., *A Parcel of Ribbons* (Lulu, 2012)
This book consists of transcriptions of letters of the Lee and Bevan families which unfortunately (from the point of view of anyone interested in Mrs Mortimer) stops at 1800. The book is the result of family history research and the author has had access to a collection of manuscript material which is presumably substantially the same as that used by Gamble and Meyer.

Pruzan, Todd, *The Clumsiest People in Europe* (New York, 2005)
See Chapter Eleven for an evaluation of this regrettable book which gives a very inaccurate picture of Favell's personality and work.

Purcell, Edmund Sheridan, *Life of Cardinal Manning, Archbishop of Westminster* (London, 1896)

Rose, Hugh James and Maitland, Samuel Roffey, *British Magazine and Monthly Register of Religious and Ecclesiastical Information* Volume 14, 1838.

Ross Dix, John, *Pen Pictures of Popular English Preachers* (London, 1852)

The Preacher, containing Sermons by Eminent Living Divines Vol. 2 (London, 1831)

Tomkins, Stephen, *The Clapham Sect* (Oxford, 2010)

Webster, Nesta, *Spacious Days* (London, 1949) [Webster]
Nesta Webster (1876-1960) was Favell's niece. She was too young to have known her personally as Favell was already in her final years when she was born. Younger sister of Edwyn Bevan, she relates his comments about Favell's marriage uncritically. She did not share Favell's faith and she is more prepared than Louisa Meyer to provide negative information.

Whately, Richard, *The Errors of Romanism Traced to Their Origin in Human Nature* (London, 1830)

Wrottesley, A.J., *The Midland and Great Northern Joint Railway* (Newton Abbot, 1970)

Young, Mary Blamire, *Richard Wilton: A Forgotten Victorian* (London, 1967) [Wilton]
This book has some interesting information from the Broseley period of Favell's life but is unreliable (when it comes to Favell) as it uses unchecked inaccurate information passed down through

the family of Lethbridge Moore. Richard Wilton's daughter Emma Storrs Wilton (b. 1856) married the architect Temple Lushington Moore (1856-1920) nephew of Lethbridge Moore, the Mortimers' adopted son.

Endnote

[251]Webster, p. 12.